Professional Photographic Illustration Techniques

Kodak Publication No. O-16

©Eastman Kodak Company, 1978

First Edition, First Printing

Library of Congress Catalog Card Number 77-99272

Standard Book Number 0-87985-190-2

Foreword

After the First World War, in the flush of the first photo-advertising era, there rose a group of great commercial photographers. Masters of the studio camera, inventing and manufacturing equipment as they went, these pioneers evolved the basic illustration techniques that are used today. Because they thought of photography as a lasting and continuing art, they passed their secrets—and carefully guarded secrets they were—to their few apprentices and assistants. The years have passed, and those first master advertising photographers have gradually left the field to their students. Today, Eastman Kodak Company is indeed fortunate to have among its customers a large group of very talented and successful professionals. These photographers have studied and worked hard to attain their high level of success and could rightfully maintain silence about their techniques, revealing them only to a select few. However, when approached through Kodak Technical Sales Representatives, they willingly searched their files for favorite examples, wrote descriptive copy, and drew lighting diagrams in order to share their knowledge unselfishly with the readers of this publication. Therefore, to these modern teachers of the art of photographic illustration (truly teachers for they teach by example, as did *their* tutors)—this book is gratefully dedicated.

ABOUT THE COVERS

In a blaze of electronic light, one of Madison Avenue's modern photographic illustrators completes an assignment. This moment is the culmination of a number of weeks of conferences, planning sessions, prop-gathering expeditions, and photographic testing for the late Albert Gommi in order to produce the illustrations on pages 109-110. Photo by Bill Reedy.

Contrasting with the front cover, this Robert Sinnott cartoon of the late Nickolas Muray, master color photographer, portraitist, teacher, and photo illustrator in the grand manner, parodies, not too broadly, the photographic methods of an earlier generation. Mr. Muray's collected works now repose at the International Museum of Photography at George Eastman House.

ABOUT THE ILLUSTRATIONS

The photographic illustrations in this Data Book were made entirely by commercial photographers working in the field. A number of the pictures, those illustrating step-by-step lighting techniques, were made on commission expressly for this publication. The majority of the pictures, however, were selected with great difficulty from groups of illustrations submitted by each photographer.

Each picture was selected to exemplify some special technical or aesthetic detail of photographic illustration. However, in studying these pictures for the special information which they convey, be sure to appreciate also their overall effect as beautiful, well-composed works of commercial photographic art, for that is what they truly are.

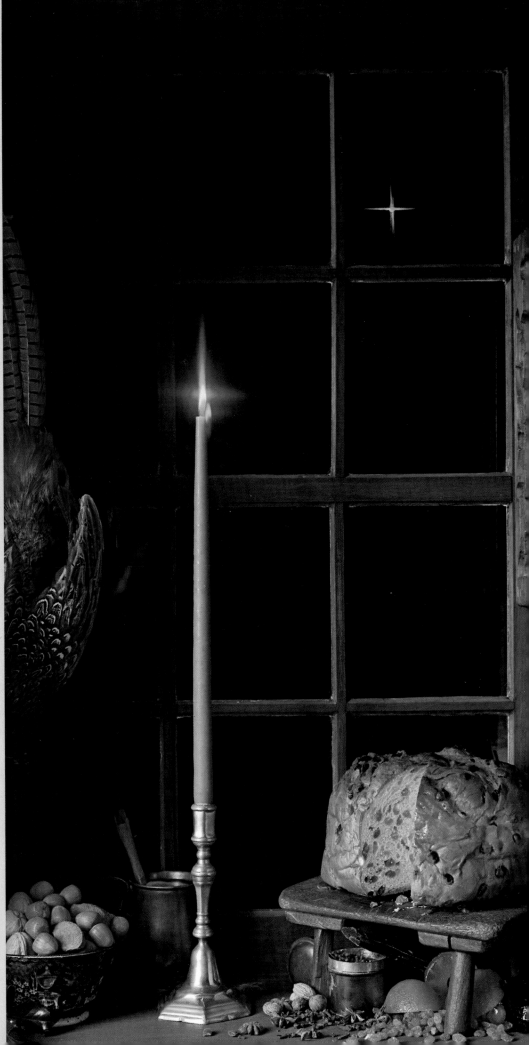

For their willingness to share their techniques and their ideas (quoted in italics in the captions) with the profession, our heartfelt thanks go to the photographic artists listed alphabetically below.

Antoni Alba, Barcelona, SPAIN
Chuck Ashley, Sausalito, CA
Steve Berman, Los Angeles, CA
Roger Bester, Sao Paulo, BRAZIL
Fred Burrell, New York, NY
Ben Calvo, New York, NY
Tom Carroll, Malibu, CA
Frank J. Chiulli, San Francisco, CA
Arnold DelCarlo, Santa Clara, CA
Fred English, Redwood City, CA
William Fotiades, New York, NY
Tony Garcia, New York, NY
Albert Gommi, New York, NY
Grignon Studios, Chicago, IL
William Groendyke, New York, NY
H. David Hartman, New York, NY
Irwin Horowitz, New York, NY
Anson Hosley, Rochester, NY
Jim Johnson, Chicago, IL
Sam Kanterman, New York, NY
Albert Karp, New York, NY
Ron Kelley, Santa Barbara, CA
Fitz H. Lee, Chicago, IL
Fred Lyon, Sausalito, CA
William McCracken, New York, NY
Bruce McLaughlin, Rochester, NY
John McSherry, New York, NY
Ed Nano, Cleveland, OH
Sam Novak, Chicago, IL
Jerry Peterson, Los Angeles, CA
Ted Pobiner Studios, New York, NY
Phil Preston, New York, NY
William A. Reedy, Rochester, NY
Dieter Schmitz, Zurich, SWITZERLAND
William K. Sladcik, Chicago, IL
Allen A. Snook, Chicago, IL
Walter Storck, New York, NY
Bill Viola, New York, NY
Charles Weckler, San Francisco, CA
Mitch Weinstock, Chicago, IL
Jerry West, New York, NY
Bjorn Winter, Los Angeles, CA
Earl Wood, San Francisco, CA

The credits with each photograph read as follows:
Photographer-Photo Studio,
Art Director/Advertising Agency, for Client.

Photographer: WILLIAM FOTIADES
*for House and Garden—Christmas
Cookbook*/Copyright Condé Nast

TABLE OF CONTENTS

A Brief History

From the very first days of photography, the artifacts of man have been subject matter for the camera. Although, in the beginning, the primary goal of the art seems to have been to make a satisfying portrait, the early photographic materials were so low in sensitivity to light that usually only inanimate objects could be captured successfully. Therefore, photographers followed the examples of the still-life painters, and soon photographs of marble busts, bowls of fruit, and vases of flowers adorned many Victorian living rooms. This form of photography became such an art that, even after improvements in the light-sensitive emulsions made portraiture a lucrative profession, still-life photographs remained popular. Today, professional still-life photographs make up a large portion of the total number of exposures, to be used not just as wall decorations, but primarily as product illustrations to be used with some form of sales promotion.

The advent of the War Between the States in America and public hunger for news of the conflict led to greatly increased newspaper and magazine circulation. The manufacture of cheap newsprint and the invention of larger printing presses implemented the nationwide daily newspaper coverage. Advertisers, appreciating this larger audience, changed their presentation techniques from mere product announcements to elaborately illustrated exhortations to purchase. Thus began photography's long and successful partnership with the advertising industry.

At first, photographs of products were used only as copy for skilled artists, who converted the images into woodcuts and steel engravings for the printing press. With the development of photoengraving (actually discovered by Joseph Nicephore Niepce of France in 1826) and the invention of the halftone screen by Max and Louis Levy of Philadelphia in 1883, the photographic image began a life of its own in the printing industry. By the turn of the century, photoengraved halftone plates were rapidly replacing woodcut illustrations of products as the sales managers of America's mushrooming industries discovered that pictures sold goods more effectively than any other medium. None learned this better than the members of the newly born catalog sales corporations. Selling products by mail to customers who had never seen the product, and in many cases didn't know what it was used for, demanded detailed illustrations of the item, usually in use. Product photography was the answer. Today, the catalog industry demands, and gets, some of the finest product photography produced—and pays well for it too.

This is only part of the full story. Photographic illustration has grown with the advertising industry through innumerable phases to become essential to the modern way of doing business.

INTRODUCTION

This book might more properly be titled "Some Professional Photographic Illustration Techniques," for no single book could, if it were a hundred times the length of this, cover all the methods of taking photographs for commercial use. From aerial to zoological photography, the manner and ways of capturing the image are as varied as the subjects themselves.

First the book presents the basics of still-life photography and illustrates various applications of these basics. Next it discusses the problems pertaining to several broad photographic categories and finally it offers a series of unusual, thought-provoking, problem-solving illustrations.

This is a book of photography by photographers for those presently engaged in the profession and those who are aspiring to it. It assumes that the reader knows basic photographic theory. It presents the illustrations and diagrams their lighting, not to be copied thoughtlessly, but to be studied and improved upon by the reader as he or she encounters similar or individual photographic problems. It is written with the idea that the commercial photographic illustrator has a job to do and that anything that provides more proficiency with tools and more efficiency with time is worth presenting.

The Tools

Before getting to the fundamentals of photographic illustration techniques, perhaps a discussion of the tools of the trade is in order.

The Camera:

Instruments for holding the film and making exposures come in endless variety. With all of their attachments and intricacies, professional still cameras can be divided into three categories:

The large-format view camera: The view camera is the traditional tool of the commercial photographer. Virtually unchanged for a century, it is a lighttight box, made flexible in one dimension by a folding bellows. One end contains a lens; the other contains a contrivance to position a film holder containing a single sheet of film per side, and a ground-glass viewing screen. Its front and back planes are adjustable in relation to the folding sides so that they can be made to pivot, swing, rise, and fall. Proper use of these adjustments can correct diverging lines or change planes of sharpness so that ultimate control of the image is possible. View cameras are available in a number of standard sizes. The 8 x 10-inch view camera is usually the largest studio camera today and is used where the highest quality of technical work is mandatory. Its large format and multiple adjustments help provide nearly grain-free photographs in which the subject is in complete focus—two of the criteria of commercial photographic excellence. Since the product of the commercial photographer—the negative or transparency that has been exposed—usually is not an end in itself, but must undergo further manipulations to be reproduced in advertising media, good photographic quality is a prime asset. A long tonal range, from shadow detail to modeling in the highlights, is required. Care in adjusting the lighting ratios and calculating exposures, along with the use of well-formulated, immaculately clean lenses, will improve the photo-

graphic quality in any format. Large cameras produce high-quality images because the films do not have to be drastically enlarged to reproduction size, thus they meet another criterion of quality—lack of apparent photographic grain in the image. Image sharpness is vital. Again, good lenses and cleanliness count, but the wide-ranging adjustability of the view camera makes it superior to other types. Perhaps another reason for this superiority of large-format-camera images is that the environment in which they usually are used—the studio—is, in itself, completely controllable. And with a large view camera, there is your picture, upside down and laterally reversed, but available for deliberate study and improvement long before the exposure is made.

Smaller view cameras—5 x 7 inches and 4 x 5 inches in size—may or may not have the same adjustable elements that the large studio camera has, but they all have the ground-glass viewing feature. They also use sheet film but offer a greater degree of portability, which is necessary for more comfortable location or outdoor work. However, with any view camera, a sturdy tripod is still a mandatory accessory.

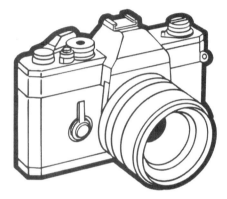

Medium-format cameras: In the second category of camera types is the group that uses 120-size roll film. These cameras usually produce an image that is approximately 2¼ x 2¼ inches in size. Increased portability and ease of manipulation make the 120 camera ideal for situations where a peak point of action must be captured, or where a model's expression is important. This hand-held, easily focused camera produces many images rapidly and effortlessly, thus building creativity exposure by exposure and freeing the photographer of the single point of view imposed by the tripod. Location work becomes to a lesser extent a matter of logistics. The camera's maneuverability makes for more interesting angles and points of view. The film size, although not so conducive to top quality reproduction as the 8 x 10-inch format, is still large enough to be studied without magnification, and it can be retouched—with care—by experts.

Small-format (35 mm) cameras: Finally, the third category of professional picture-taking equipment is the 35 mm camera. This most personal of photographic mechanisms is used at eye level to record exactly what the eye sees. In fact, the 35 mm camera has been called an extension of the eye. There are several varieties of the 35 mm camera: the single-lens reflex, which uses the same lens both to view the subject and to record it; the rangefinder camera, which uses a split-image or overlapping-field focusing system and is instantly ready for multiple exposures or, when coupled with a motor drive, has the ability to capture multiple sequences with the rapidity of a motion picture camera; cameras small enough to fit in the palm of the hand, yet with the versatility made possible by the ability to accept lenses of many focal lengths. Designed for action, for intimacy with the subject, for recording every visual stimulation, no wonder 35 mm is by far the most popular format.

Which of these three categories of cameras is the best one for the commercial illustrator? There is no *one* best camera format. There is only one best camera for each photographic situation. The photographer must be able to choose which best fills the need.

The Lens

Often compared with the human eye, the photographic lens is capable of transmitting all the colors and tonal qualities of a scene to the recording plane of the light-sensitive film. However, unlike the intellect-controlled eye, the camera lens "sees" all objects with equal intensity. To make a story-telling picture from the scene before this arrangement of carefully formulated glass disks, the photographer must control the tonal qualities of the image, highlighting and focusing on the subject, and de-emphasizing the extraneous so that the film records the scene differentially.

Through its focal length the lens controls the area of the scene that is recorded on the film. A lens of normal focal length records approximately the same area as does the eye. A longer-than-normal focal length lens, usually referred to as a telephoto lens, records less area of the scene, but the objects in it become larger. A shorter-than-normal focal length lens records more area, with smaller-sized objects. A short focal length lens is called a wide-angle lens. Normal focal length is related directly to the film size of the camera. A normal lens has a focal length roughly equivalent to the diagonal of the film rectangle, 12.8 to 14 inches for an 8 x 10-inch film, 80 mm for a 2¼ x 2¼-inch format, and 50 mm for 35 mm images.

Modern cameras easily accept lenses of widely varying focal lengths. From the 400 mm lens whose recorded image is illustrated on page 14, to the 7.5 mm fish-eye lens image on page 15, the 35 mm camera, as well as cameras of other formats, can be used to emphasize features of a scene at the whim of the photographer by changing the focal length of the lens with which it is equipped.

Filters: An important footnote to any discussion of the lens as a photographic tool is the mention of optical filters and their use. The appearance of a black-and-white or a color photograph can be changed either drastically or slightly by the use of a filter over the camera lens.

The density of colored areas in a scene exposed on panchromatic black-and-white film can be lightened by using a color filter of the same hue over the lens. Conversely, by using a filter of a complementary color, the same areas can be darkened.

Color compensating (CC) filters are routinely used to fine-tune the color recording characteristics of professional transparency films, and supplementary data are included in the instruction sheets packaged with a number of Kodak films. In addition, CC filters can be used, with discretion, to enhance subject color in a picture by subtly biasing the color balance of the film in its favor.

Special optical devices, such as star filters, haze filters, diffusion filters, and diffraction gratings, contribute striking effects to select photographs. A number of examples are included in this publication.

Finally, a measure of protection to lens surfaces from physical damage and to camera films from ultraviolet radiation can be afforded by permanently affixing a glass-bound skylight filter, such as a KODAK WRATTEN Filter No. 1A, to your lens. No additional exposure is required for this measure.

Kodak Publication No. B-3, *KODAK Filters for Scientific and Technical Uses,* sold by your professional photo dealer, lists and gives the uses for a wide range of filters for photographic and technical work. This publication is also available from Eastman Kodak Company. See inside back cover for more information.

The Film

Another versatile tool in the hands of the professional photographer is the light-sensitive material upon which the subject is recorded. The film chosen will affect the result in a number of ways. Black-and-white film choices include materials with very fine grain for fine detail or great enlargement; films of extremely high speed, used in low-light situations; and films inherently high or low in contrast. The photographer's choice will depend upon the subject and the final use to which the photographs will be put.

Kodak Publication No. F-5, *KODAK Professional Black-and-white Films*, contains a complete listing of such films manufactured by Kodak and extensive information regarding their use. It is sold by most photo dealers or is available from Eastman Kodak Company. See inside back cover.

In the case of color photography, the situation is slightly different. Color transparencies are, themselves, the finished product as far as the photographer is concerned. From them, photomechanical reproductions are made directly. Because color transparency materials must be critically exposed to obtain the exact results desired, tests and bracketed exposures are the rule, not only to be sure of capturing the subject, but in order to have a choice of a slightly high key, normal, or color saturated rendition.

Color negative films offer more latitude in exposure because much control is available in making the color print or print film transparency for which the color negative is the intermediate step. Control, not only in making corrections in basic exposures, but in making areas that are darker than or different in color from those in the original scene, is at the hand of the experienced darkroom technician, giving the photographer even further benefits.

Kodak Publication No. E-77, *KODAK Color Films*, containing extensive data and information on handling and processing Kodak still color materials, is available at most photo dealers or from Eastman Kodak.

These then are the light-sensitive tools of the photographer. In themselves, they are minor miracles, but without some effort on the part of the person who uses them, they cannot be used to their fullest potential. Use a variety of films for testing and evaluation in as many situations as possible. When you are thoroughly familiar with their characteristics, make your choice of one basic film for each problem. Then stick to that film. Use it until you are completely confident of your ability to control it. You will find that you can almost predict the proper exposure indicated by your meter. When you can use your film as easily as you handle your camera, your concentration can be toward the real problems in front of the lens.

9

The Lights

All photographs require a sufficient amount of light to permit exposure. Originally, the photographer depended upon the sun for all exposures—indoors and out. Then came a series of artificial illuminants—from candles and kerosene lamps to carbon arcs. Today there are two main methods of producing artificial light for general photographic use: incandescent lamps and electronic discharge lamps, usually called strobes. Accompanying the light-producing element of each piece of photographic lighting equipment is some means of controlling the quality and direction of its light. Lenses, reflectors, baffles, diffusers, barndoors, snoots, umbrellas, bounce boards—all are necessary to produce the desired effect.

The following is a specific commentary on various types of lighting equipment and some of the techniques employed in using them.

Spotlights: The optically adjustable spotlight is one of the more important lights to be found in a studio. Used at any range, it delivers light of a relatively high intensity with a definite sharp-cutting quality. Since its rays of light are collimated by the Fresnel lens, it doesn't go around corners. Thus, it sharply chisels the highlight areas away from the shadows. It is in this application that it plays the most important role, since it can give a subject a great deal of shape and bulk. In addition, when applied to a surface in a skimming fashion, it renders texture in a most crisp manner. Its relatively low flare level produces highest saturation levels and contrast. Aside from the quality of the light produced, the usefulness of a spotlight is greatly increased by its controllability. Isolated puddles of light can be made, areas of localized light can be produced from great distances, and unwanted spillage onto other areas can be avoided easily. Perhaps one disadvantage can be found in the quality of the specular highlights that are formed on some subject surfaces. The speculars are harsh and pinpointed, difficult to avoid. Nevertheless, the spotlight is a most effective key light for products, scenes, and settings.

Miniature spotlights play a key role in lighting situations, not as main lights, but as accent lights and as localized fill lights. Placing them low on tabletop sets permits the photographer to skim

efficiently the surfaces of objects to enhance textures. Keeping them low and needled down (or snooted) permits light only where needed, and thus unwanted secondary shadows can be avoided. As localized fill lights, they are ideal for brightening small shadow pockets without illuminating everything on the set. When they are used near the camera axis, the newly created shadows are usually concealed behind the subject.

A final comment on spotlights in regard to the accessories available for them: Owning a spotlight without a full line of snoots and barndoors places great limits upon the light's uses. An important factor in the use of a spotlight is the degree of control possible with the focused beam. The control can be greatly extended through the use of accessories.

Floodlights: The general term "floodlights" encompasses many types of lights, ranging from miniature high-intensity reflectors to large, broad, multi-bedded pans. While all lights called flood have one thing in common—their ability to cover a large area with reasonably even light—that is about all they have in common. The quality of light from these different types of floods varies considerably. Here are some of the more common types with some comments about each:

RFL Sealed-Beam Flood Bulbs: Essentially, these bulbs are designed to be lightweight miniature sources of light. Their internal reflectors are intended to spread light evenly over a large area, usually about 120 degrees from the point of origin. The quality of the light is greatly affected by the limited size of the bulb diameter. Used at any range beyond 4 or 5 feet, they have the sharp shadow and harsh highlight quality of a spotlight with the even-spread quality of a floodlight. The only way to adjust the quality is either to bounce them off a large surface or diffuse them at a distance with a large scrim of diffusion material.

High-Intensity Miniature Units: Quartz-iodine type bulbs are generally the light source here. Advantages are to be found in the extremely high intensity of these bulbs and the relatively low amperage that they draw. Disadvantages are to be found in the high operating temperatures and in the relatively small-size reflectors with which most of them are supplied. Such small reflectors create sharp shadows, harsh highlights, and at great distances have an almost spotlight-like quality. These remarkably efficient reflectors spread the light evenly over large areas, but certainly not as a soft, flattering floodlight would. Again, if a more diffuse light is desirable, the light quality would have to be altered with diffusers or bounce boards.

Parabolic Reflectors, 9 to 16 inches: The true parabolic reflector is designed around a particular light bulb size and shape. With a proper bulb in a well-designed reflector, maximum light delivery is obtained. At certain ranges, the spread pattern will be most even. Some such reflectors will produce hot spots at ranges too close or too distant. Naturally, the larger the diameter of the reflector and the closer the reflector is to the subject, the more diffuse in quality the light will be. The quality of the light is also affected by the kind of reflector surface. Metallic, chrome-plated reflectors are specular and sparkling in quality, whereas matte-silvered surfaces tend toward softer qualities. Using frosted bulbs can change the quality of the specular highlights and the shadows to more diffuse characteristics. Clear glass bulbs create a specular highlight within the diffuse highlight and a sharper-edged shadow within the soft-edged shadow.

Larger Scoop Lights, Broads, Pans: All of the same principles mentioned above are applicable to these lights. Each light has distinct qualities based upon its diameter, its depth, its reflector surface, and the size and kind of bulb. Large diameter lights are unsurpassed for covering huge areas at great distances. In addition, their large diameter produces light of softer quality, shadows that are softer edged, and highlights that are less specular. Multi-bulbed units are particularly good in this respect when the reflector is of proper design to integrate the light from the several bulbs. If each bulb creates a separate, obvious highlight and shadow, in addition to the overall highlight and shadow of the reflector, most photographers will find the unit objectionable.

Bounce Light, Umbrellas: The use of "ambient" quality light, light coming from a general direction with no obvious point source, has increased greatly in the past years. The quality is pleasant, as the light envelopes the subject with soft, flattering illumination, gently tracing curves and shapes, and producing soft but meaningful shadows. Umbrellas do it well and efficiently. Being large and almost parabolic in concept, they are more efficient than flat walls, ceilings, and tents. Large, curved sheets of white card, "spinnakers," are directional, but they yield soft, diffuse light of an excellent quality. A useful technique for small-set photography is to place the bounce board close to the subject and hit the board with light from a distance (use of a spotlight as the light source helps to limit the light to the card surface). Combinations of bounce light and direct light can be had simply by placing a bare bulb right in front of a large white bounce board. This light almost makes its own fill.

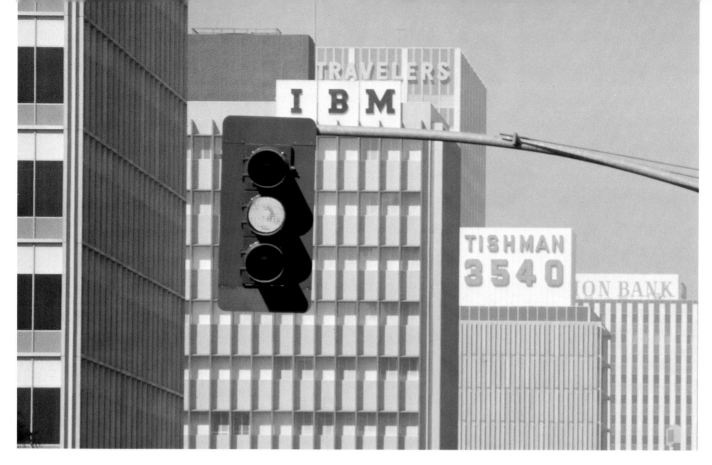

Photographer: TOM CARROLL
for IBM Corp.

Two views from the same vantage point; with a 21 mm lens and a 400 mm lens on 35 mm KODACHROME Film.

The telephoto lens is a very useful tool to compress, posterize, or simplify. This long-lens shot projects a feeling of power. Red and green didn't work, but the yellow caution light contrasts nicely against the gray. For an IBM ad on computerized traffic control.

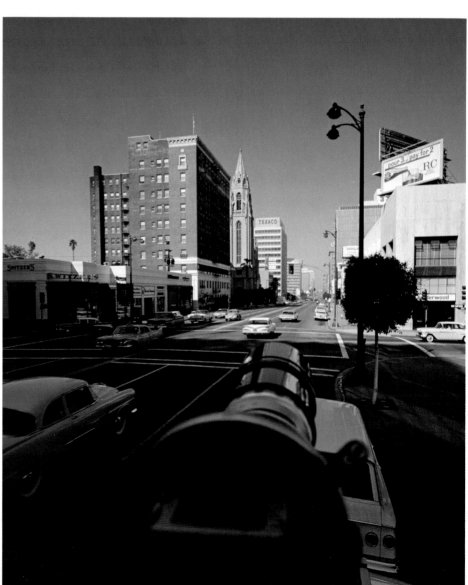

Photographer: BRUCE McLAUGHLIN
Sharon Knitzel for Supreme Equipment and Systems Corporation

The fish-eye lens is a marvel of optical engineering, but unless the subject is chosen with care, the resulting picture looks gimmicky. A 7.5 mm lens was used here to relieve the stark vertical and horizontal lines of a huge bank check filing machine and to emphasize the cruciform shape of its travelling retrieval unit. Because of the wide angle of view with this lens, the two sealed-beam floodlights used to light the interior of the machine were actually placed behind the camera. On KODAK EKTACHROME Film 135.

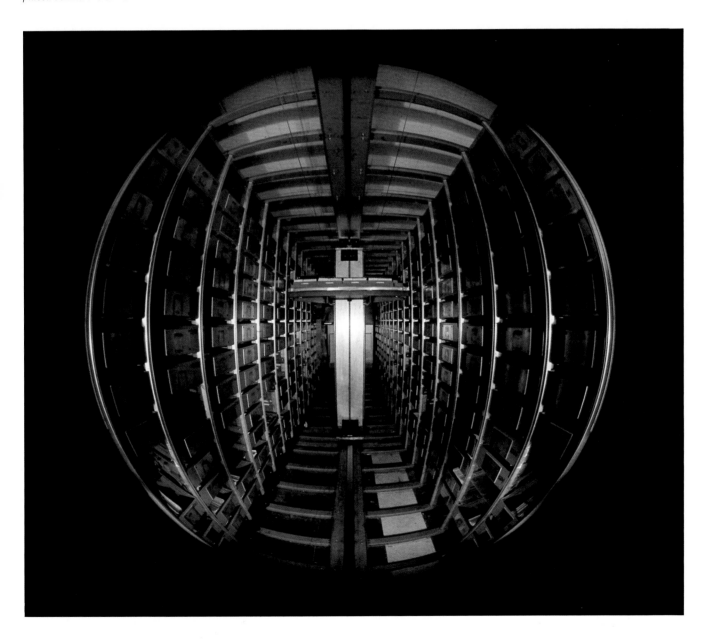

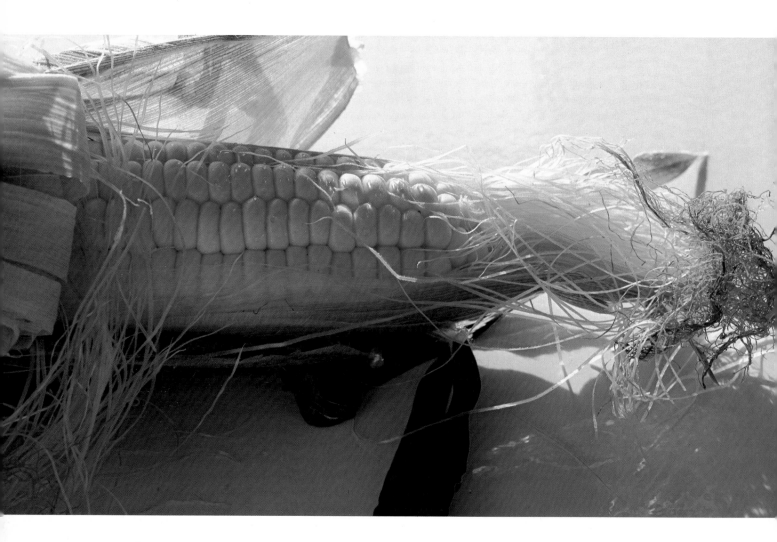

Photographer: WILLIAM K. SLADCIK

This photograph actually came about through experimentation with many different vegetables. Deciding upon this ear of corn, I used a sun-filled window as the light source. The direct sunlight was diffused with a sheet of tissue paper and a slight amount of fill light was reflected from a small white card near the camera. I feel that this photograph could not have been accomplished by using either tungsten or electronic-flash lighting because of the unique quality of true daylight, which cannot be duplicated. On KODAK EKTACHROME Professional Film, Daylight, 8 x 10.

Photographer: SAM NOVAK
for Sears, Roebuck and Company

The objectives in photographing this lovely sculptured carpet were: A. To excite the viewer's eye. B. To present the client's product in a manner that is descriptive and interesting. C. To make the photo appear as natural looking as possible. A 2000-watt spotlight was placed low to the left to bring out the rug's texture in the foreground. A 4 x 8-foot bank of diffused 500-watt reflector floods filled the doorway on the right. The window at the rear of the set was covered with matte acetate and lighted with a 2000-watt focusable quartz light. An 8 x 10 Deardorff camera, with a 14-inch lens was used to expose KODAK EKTACHROME Film.

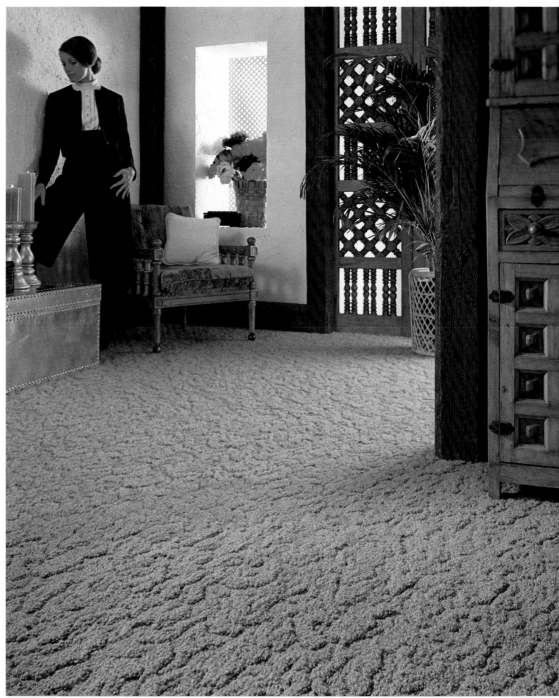

Photographer: ROGER BESTER
for *Quatro Rodas*/Editora Abril

This shot was for a special edition of the magazine "Quatro Rodas." The edition is called "4 Rodas MAR" (Four Wheels—The Sea). It is an editorial shot, a double-page spread opening a section on seafoods. The lobster was one of three I had to choose from and has certain retouched features—namely the legs. It also has highlights of olive oil painted on it, but otherwise is quite genuine. I rather feel that this kind of photography will be my specialty.

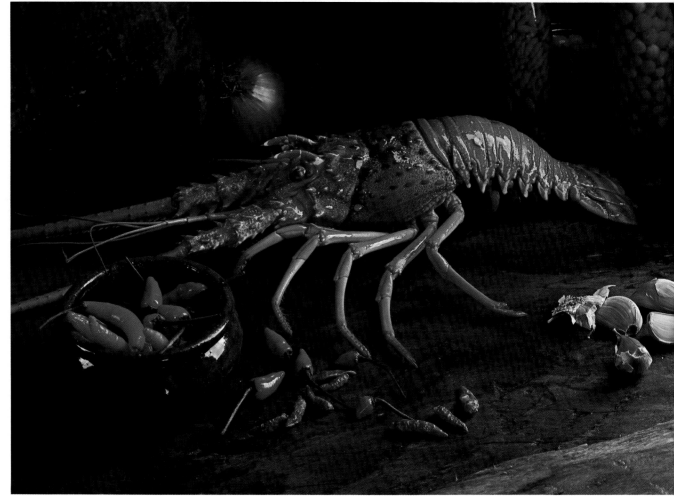

Photographer: ROGER BESTER
for *Quatro Rodas*/Editora Abril

An illustration of the uses of carefully placed spotlights. Note the dominance of the "kicker" lights at right and left rear of the set, usually used only as accents.

The Toymaker was shot as a publicity handout to agencies to promote a subsidiary magazine to the already very well established car and tourism magazine "Quatro Rodas" (Four Wheels). It is published by Editora Abril, Sao Paulo, Brazil. The new venture is an edition entitled "Quatro Rodas Hobby." (The English word is used in Portuguese.)
 I was both the art director and photographer of this picture from an idea given to me by the director of the magazine. I used electronic flash, heavily shaded with barndoors and directed at specific areas of the set. Seven 1200-joule Balcar power units were used on the final shooting done on f/22 with a 4 x 5 Sinar camera, a 150 mm lens, on KODAK EKTACHROME Professional Film, Daylight.

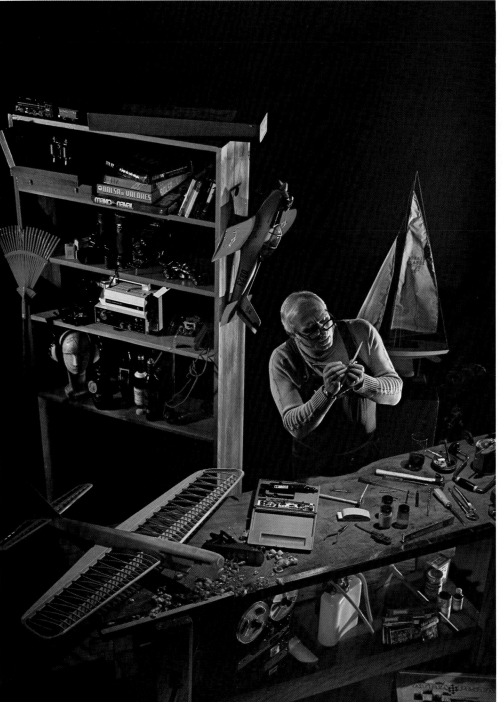

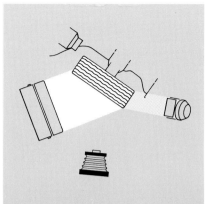

Photographer: ED NANO
Studio Associates, Lang, Fisher, and
Stashower Advertising Incorporated for Seiberling Rubber Company

Photographing an automobile tire so that the distinctive tread design
and sidewall markings are visible is something like taking a picture of
a black cat in a coal bin. Here are two versions of such a difficult task;
the first one taken with spotlights as primary sources of illumination,
and the second lighted with soft floods.

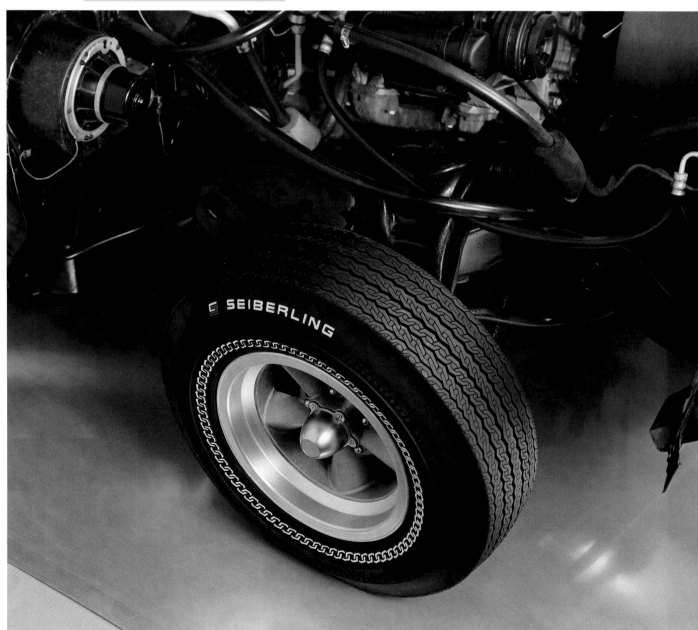

The simulated night scene for a double-page advertisement was done in the studio. The background was of black vinyl—wet. Four 1000-watt floodlights bounced against a large curved white reflector to the left of the camera provided general illumination. A 750-watt spot, to the right of the camera, was directed on the tire tread. Another 750-watt spot covered with a green gel from the back of the set reflected under the car, and a 650-watt red-gelled spot from the left rear added color and dimension to the side of the car. An 8 x 10 Kardon camera with a 14-inch lens was used to expose EKTACHROME Professional Film over a range of exposure.

The second photograph is actually half of the illustration. The other half is a "ghost" image of the car fender and hood, through which you can see the tire. The two were merged by means of a dye transfer print from two transparencies. The floor of this set consisted of a sheet of stainless steel. The tire tread was illuminated with a 1000-watt quartz light, placed high. The main light was a 4000-watt Softlite flood. An 8 x 10 camera with a 19-inch lens loaded with EKTACHROME Professional Film was used from a high angle.

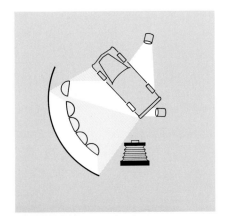

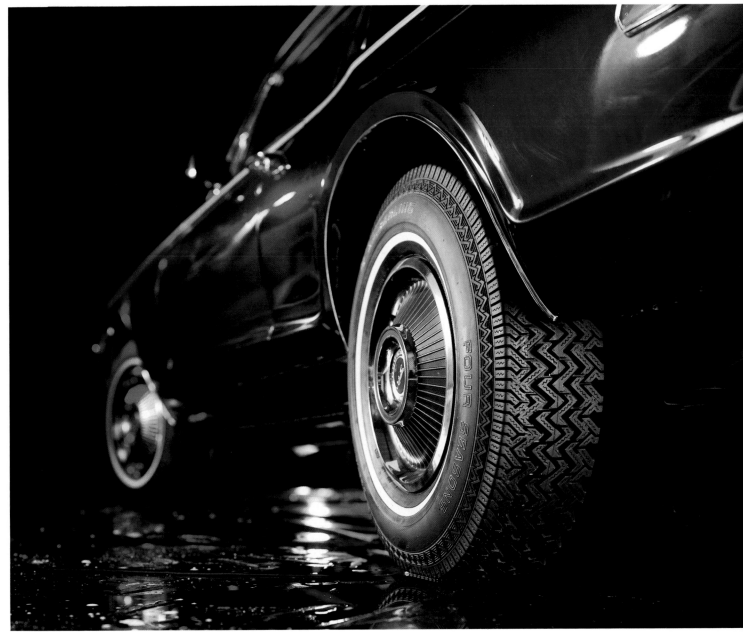

Photographer: TOM CARROLL
Boylhart, Lovett and Dean, Inc. for Doloco Packaging Inc.

These photos of huge rolls of egg-carton plastic taken for an annual report assignment show the effect of a single high-intensity light and its placement 30 feet away when used in a mixed-light source situation.

The light is the Lowell Tote 1000-watt lamp with a color-correction gel to balance with an overhead fluorescent unit. I prefer to use tungsten or quartz lighting whenever possible on location since it allows me freedom in shooting to take full advantage of the 35 mm system. An electronic flash distracts even the most sophisticated subject. It also freezes the action, which in most cases also freezes the picture. Of course, there are times and places when electronic flash is the best and only answer.

Because I process my own film in a Merz B2A tube processor, using throw-away chemicals, I rate my EKTACHROME Film three stops above the normal ASA rating.

On these annual report assignments, I shoot black-and-white and color at the same time, using two Nikon cameras. I rate both films and compensate for this extra-high film speed in processing. On assignment I average 1500+ exposures a day. 99 percent are hand-held, including close-ups, photomicrographs, etc. Stay sober, get plenty of rest, and believe *you can do it!*

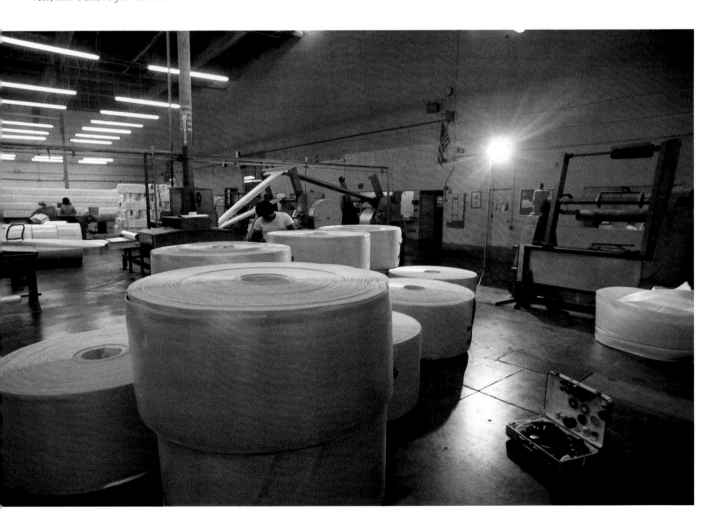

Basic
Lighting

Every photograph is an exercise in lighting, whether by arranging artificial illumination around the subject or by arranging the subject according to the available natural illumination. Given a product as a studio subject, you, the photographer, must determine how best to present it. Aside from a layout or picture idea which tells how the product is used or illustrates its related surroundings, you must first deal with basic lighting. By proper arrangement of the studio lights, you must create a natural, attractive lighting that simulates outdoor daylight. Natural sunlight, whether it is clear and sharp or clouded and diffuse, is the standard of comparison for most lightings. This is a basic psychological fact that cannot be overemphasized. To creatures who have for aeons viewed their surroundings by the light of the sun, the effect of multiple highlights and "butterfly" shadows is chaotic. The light from the main source should come from above, usually at a 40- to 60-degree angle. There should be one definitely dominant light source and one set of dominant shadows. In nature, no matter how harsh the contrast of the sun becomes, our eyes—because of their variable sensitivity—can always discern shadow detail. Therefore, the average studio lighting setup should also have sufficient shadow illumination to register on the film. Nature accomplishes this shadow illumination by means of general skylight scatter. In the studio, soft fill lights and reflectors are used to light the shadows, usually in a 3 to 4:1 ratio.

The outdoor effect of an overcast sky has its counterpart in the studio when translucent tents or completely indirect lighting is used to illuminate shiny objects such as jewelry or silverware.

One additional aspect of basic lighting which will help you in most setups is backlighting. Placing the main light slightly behind the subject will often help retain a three-dimensional form better than frontlighting will. The shape of the subject will be duplicated in the shape of the foreground shadow, making identification easier. Also, the subject will be brilliantly rimmed with light, outlining each shape and breaking it away from the subdued tones of the background.

Remember these basics: the high, single, main source; the soft, shadowless, fill light; and the delineating back light. These are the bare bones upon which to build your lighting, modifying and augmenting as the nature and shape of the subject demand.

The following illustrations of two of the most common shapes, the rectangular box and the sphere, show how basic lighting can be modified to emphasize shape.

Photographer:
WILLIAM FOTIADES
for *House and Garden/*
Copyright Condé Nast

For a Caribbean Cookbook. A large hibiscus plant was flown in from Florida—and we waited patiently for it to bloom. The lighting simulated tropical sunlight so well that although the original photograph was done on location, this one, assembled under the controlled conditions of a modern studio, seemed to be more convincing. Equipment: 8 x 10 Szabad Camera, Ascor Speedlights, EKTACHROME Professional Film, Daylight Type.

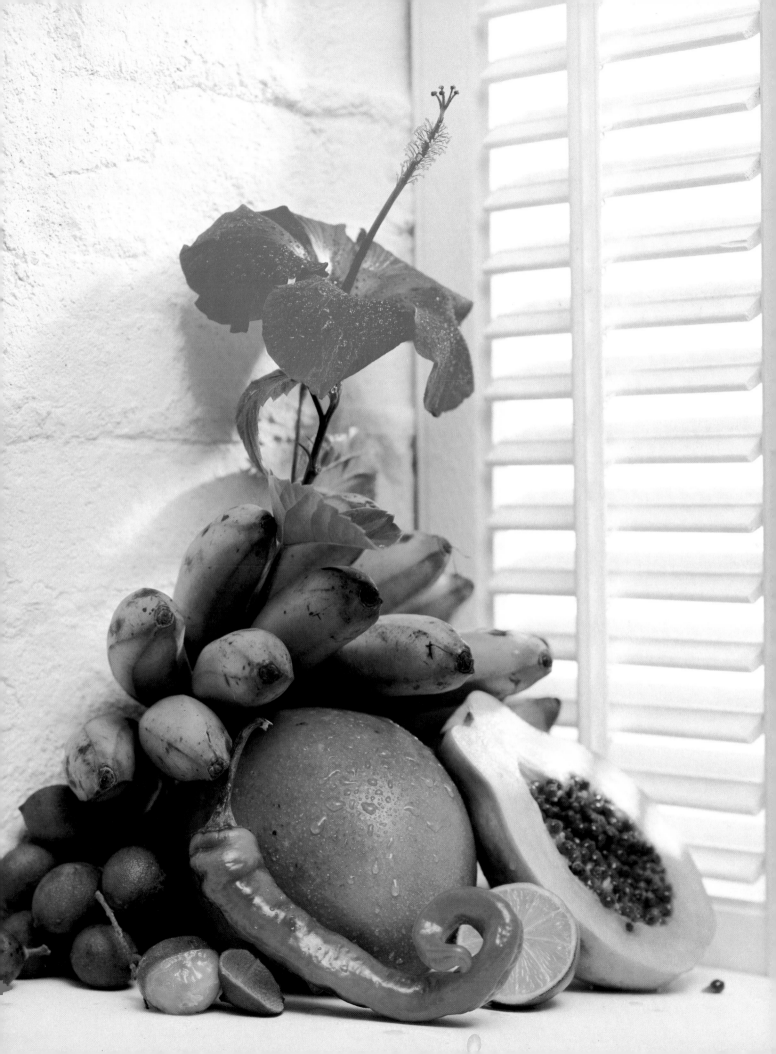

THREE-STEP LIGHTING
FOR BOX-SHAPED SUBJECTS

The problem of lighting a box, whether it be a product, its carton, or as here, a white clay brick, can be handled simply with three lights: a spotlight from left rear and two floods from each side of the camera.

a. *Here, the two equally brilliant floodlights at camera height completely flatten the subject, almost into invisibility.*

b. *Soft light from above, such as bounce light from the ceiling, is not the lighting answer; there is no contrast difference between the two frontal planes.*

c. *Build the lighting slowly, one light at a time. Here is the left front flood.*

d. *Now, add the spotlight. We're almost there.*

e. *Finally, add the right front floodlight—at about one half the intensity of the left floodlight. Note how the shadow on the background helps define the rear edges of the subject. Each of the three visible planes of the subject has its own distinct tonal quality, and a good, strong shadow helps hold the brick to the ground.*

This basic lighting procedure can apply to an infinite number of rectangular products. For example, this lighting would have been equally suitable for a package of cigarettes, a box of cereal, a cake of soap, a radio, or any other subject with a somewhat similar shape.

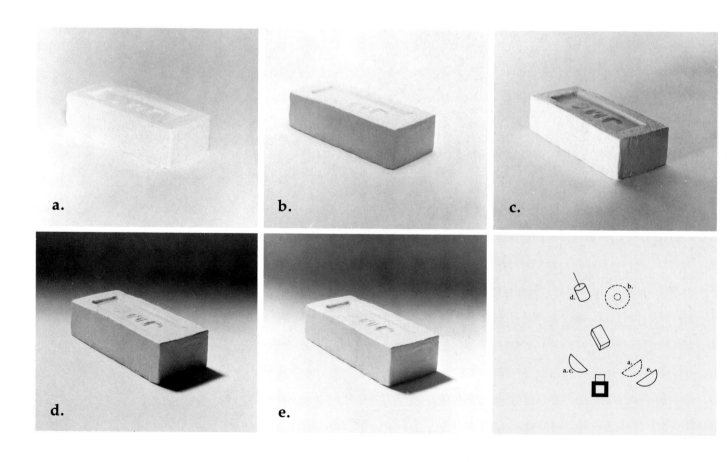

PRESERVING ROUNDNESS
IN A SPHERICAL SUBJECT

How to show the roundness and texture of an orange.

 a. Here, without light on its surface, only on the back-ground, the orange, in black-and-white, appears to be a hole cut in the background paper.

 b. First, place the main light, a spotlight, high, behind, and to the left of the subject.

 c. Another, smaller spotlight, at subject level, is in position on the left rear of the set.

 d. Added roundness is obtained by a low, third spotlight from right rear, which places a brilliant highlight on top of the main-lighted area.

 e. The combined effect of the three back lights, plus a weak fill from beside the camera, changes the effect into a completed lighting, showing maximum texture.

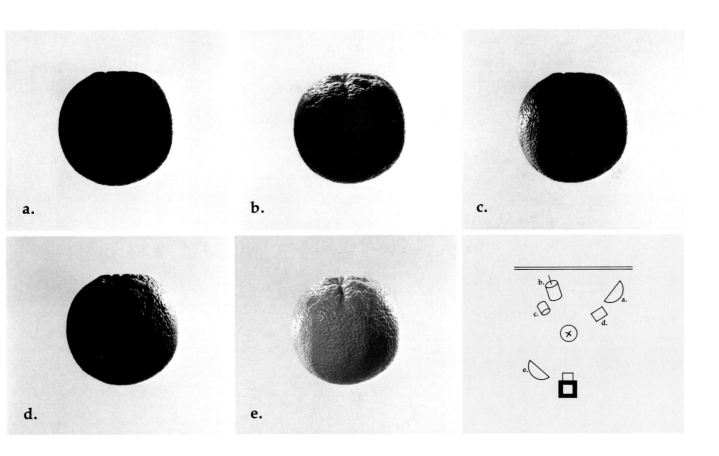

a.

b.

c.

d.

e.

Photographer: JERRY WEST
for B. Altman Company

This photograph was an assignment for an ad for B. Altman Company. The art director requested an airy, outdoor feeling. Since silver is such a reflective subject, it was necessary to build a white tent completely around the set to eliminate all reflections of dark objects. I placed five Balcar electronic flash units inside the tent, aimed to bounce off the walls and ceiling, amounting to 2400 watt-seconds of light. The exposure on 8 x 10-inch EKTACHROME Professional Film, Daylight, was one flash at f/45.

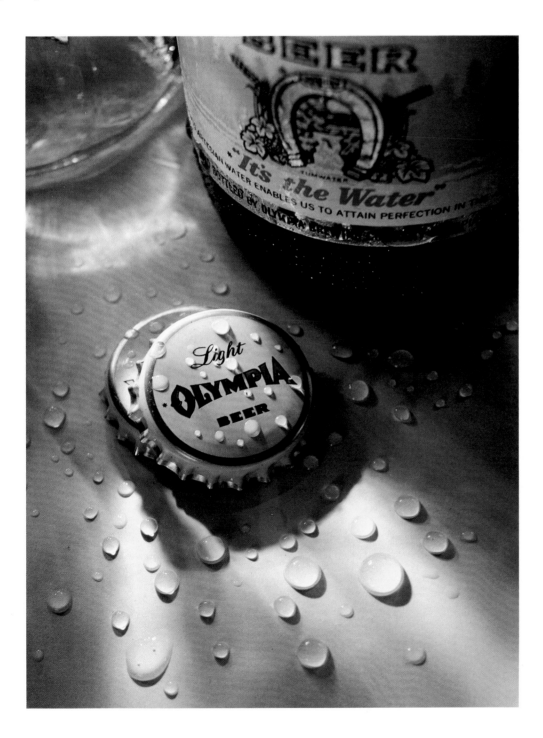

Photographer: FRED LYON
Botsford-Ketchum Inc.
for Olympia Beer

Backlighting:

This Olympia Beer ad ran as a bleed page in Life Magazine. *The intent was to startle the viewer by having the subject matter appear considerably over normal scale. The lighting consisted of a single Fresnel lens spotlight backlighting through a bottle of beer, thus gaining the lens effect of the liquid-filled glass. Fill light was provided by small white cards reflecting the primary source from just outside the picture area. Water drops were painstakingly placed on a water-proofed background with an eye-dropper and hypodermic syringe. The bottle was sprayed with an atomizer of glycerine and water. The film was KODACHROME Type A. The lens, 105 mm Nikkor.*

Photographer: ED NANO
Studio Associates Inc.,
Howard Swink Advertising for Ranco, Inc.

An illustration of high inherent subject brilliance, this cooling photograph was simply lighted from the right with four 1000-watt quartz floodlights reflected from a large curved reflector. A black gobo prevented stray light from degrading the maximum density of the black background paper. Rough-cut cedar planks and several hundred pounds of ice form a base for the product. A certain amount of fill light was obtained from the translucent ice blocks themselves, so no other fill light was necessary. Photographed with an 8 x 10 camera and 19-inch lens on EKTACHROME Professional Film.

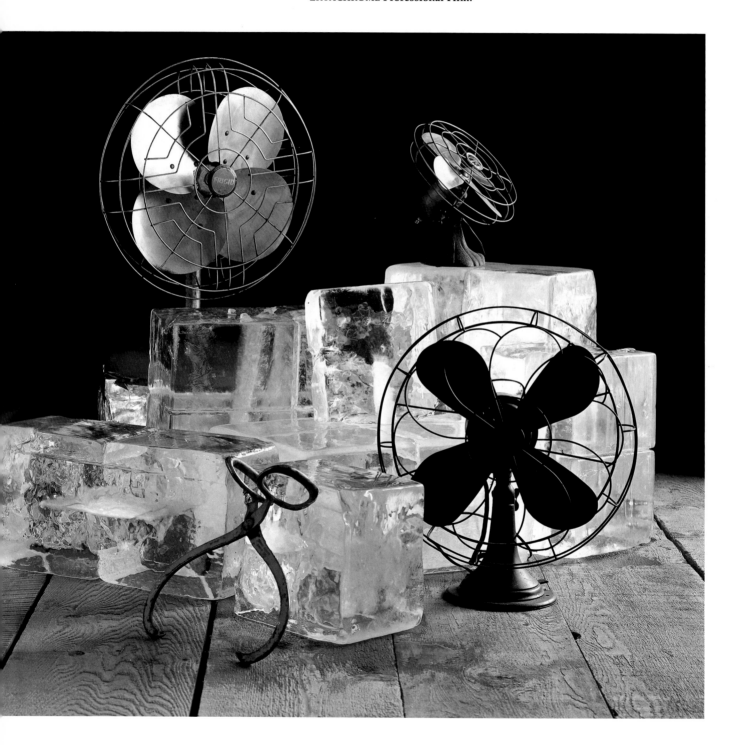

Photographer: EARL WOOD
for Skelton Photography

A photograph with low inherent subject brilliance, properly exposed with extremely flat lighting, will still produce a pleasing picture. With the exception of the green leaves, all the elements here have essentially the same reflectance value. Even the buff-colored background and floor paper did not have the brilliant reflectance quality of white. The extremely soft, directionless light was provided by bouncing two 1000-watt floods off the left wall and ceiling and three 750-watt spots off the right wall of the 14 x 20-foot all-white studio, making an effective tent (see page 54). The time exposure was made with an 8 x 10-inch camera with a 12-inch Symmar lens on EKTACHROME Film.

 Composition Note: Cover that lone rose petal with your finger and see how important it is to the success of the picture.

An Approach to Basic Lighting

Good lighting is an intentional act on the part of the photographer. Through experience, he understands his lighting equipment and the effects it will produce. When given a studio assignment, he first analyzes his subject, then visualizes the finished photograph, and finally proceeds in an orderly fashion to accomplish the visualized goal.

Here, in chronological checklist form, is one system for lighting a photograph:

1. *Visualize:* How should the subject look? What should be shown? What should be featured? Should it appear real? Should it appear beautiful? Should it appear ugly?

2. *Decide:* What kind of lighting to use. From what direction and distance. What overall quality should prevail.

3. *Choose Equipment:* What piece of equipment will be used as the main light source? Will it take more than one light to effect the main source? What adjustment to the main light source will make it most suitable? (With the main light source in place.) Is it doing the job? Is it at the correct angle and distance? Is the overall quality as visualized? Can another light do it better? Have any unforeseen problems been created? How much light do the shadows need? Should they be filled equally?

What light or lights are most appropriate to use as fill lights? (With the fill lights in place.) Have the fill lights created new problems? How can they be avoided?

4. *The Highlights:* Are they too specular? Too numerous? Can they be toned down or eliminated? Are they in the wrong places? Are they distracting?

5. *The Final Touch:* What more is needed? Are accents needed in certain places? Are accents overdone? Is every light on the set doing something vital? Can any light be eliminated? Is the lighting effective? Will it record the subject on film as it was visualized?

6. *Final Checks:* What is the exposure for the darkest shadow? What is the exposure for the brightest highlight? What is the proper exposure for the entire set? Will it conform to the film's density range?

7. *Flare:* Are any direct lights spilling onto the camera lens front element? Can any unneeded bright area be toned down to eliminate flare in the camera lens? Will the film record the visual contrast range?

8. *MAKE THE EXPOSURE.*

Photographer: FITZ H. LEE
for Kraft Foods

Positioning of the main light, high and
slightly behind the subject, is the secret of
this food advertisement. A single 1000-watt
spotlight, on a boom, beams through a
diffusing tissue paper scrim onto the subject.
Because of the placement of the single light,
the diffusion softens the beam enough to
provide exactly the correct amount of
fill light without destroying its specular
quality. On 8 x 10-inch EKTACHROME
Professional Film.

Establishing the Lighting

For most studio assignments, it is logical to establish the main light first, then any additional highlights, and finally, the necessary fill illumination. This order of establishing the lighting is arbitrary, and depends somewhat on the subject to be photographed. With interiors and objects which are to be tented, the procedure is to create first a general high level of illumination, and then add directional lighting to give the subject better form. However, 1. the main light, 2. the highlights, and 3. the fill light sequence for small-object photography is preferred because the exact effect of each light being used can be observed as it is turned on, and precise control is easily effected.

1. *The Main Light:* The customary general position of the main light—high and somewhat behind the subject—has been demonstrated on the preceding pages. The exact placement of this light is very important. One method of determining the proper main light position is as follows: With the set darkened, and your eyes as close as possible to the camera lens position, observe the effect of lighting the subject with a small, easily moved exploratory light such as a small spotlight. This light should be moved about the general area visualized for the main light source as you observe the change in the highlight and shadow areas of the subject. It is important that you observe the effect of the various light positions on the subject just as the camera will photograph it. If the camera is in the way, move it back and put your face exactly where the lens was. An alternative method is to observe the image on the ground glass while an assistant moves the exploratory light. Once the best placement is found, move the actual main lighting unit into that position. The characteristics of the main light source will determine the overall quality of the photograph. Should the main light be a flood lamp or a spotlight? Should it be near the subject or far away? The general principles of these two types of light sources are as follows: Flood lamps produce broad, diffuse highlights and

shadows with indistinct edges and some detail; spotlights produce small, specular highlights and sharp-edged shadows with very little detail. Regardless of the type of lighting unit, the greater the light-to-subject distance, the smaller the highlights and the sharper the edges of the shadows will be.

2. *Placing the Highlights:* Adding a number of small lights to a set in order to delineate the details of a subject does not seem to have its corollary in nature, until you think of the sparkling highlights on a sunlit lake that add colorful accents to shoreline foliage, or the tall clusters of red sandstone columns in Bryce Canyon that seem to glow with an inner light due to the multiple reflections from one to another of the setting sun. Therefore, in photography, we still mimic nature—but carefully—by placing flattering, plane-separating highlights where they will do the most good for the subject. Actually, the main job of the highlights is twofold: the edge-light reflection variety (from a small spotlight at the rear of the set) helps to separate subject planes, as well as to differentiate between the subject and its surroundings, thus giving it emphasis. The second variety of highlights, the texture light (from a spotlight that skims the surface of the subject from a very low position) delineates the subject's textures and thus gives a clear impression of its surface.

The positioning of lights to create desirable subject highlights can be even more painstaking than finding the main-light position. Usually, several small lights are necessary to do an adequate job of highlighting, especially if the subject has a fairly complex shape.

If you work without an assistant, the thing *not to do* is to make endless trips between camera and lights, modifying their position slightly, then rechecking the effect on the ground glass. Rather, determine the location of the highlighting units by placing a small spotlight directly in front of the lens, illuminating the subject with a sharp beam of

Photographer: RON KELLEY

for Spectrum Technology, Inc.

For a large mural in a display booth, to show, in a different way, the products of this company.

An umbrella was used as a fill light from behind the camera. Two small spots, feathered carefully on each side of the set, picked up the highlights from the polished metal and soft natural surfaces of the subjects. The base is blue aquarium pebble sand. I used driftwood with gold and silver ingots, pearls, and coins to show the value of the product in an abstract way; the idea being to contrast objects of a similar color. A 90 mm Super Angulon lens was used to give distortion and to force perspective on the 4 x 5-inch EKTACHROME Professional Film, Daylight.

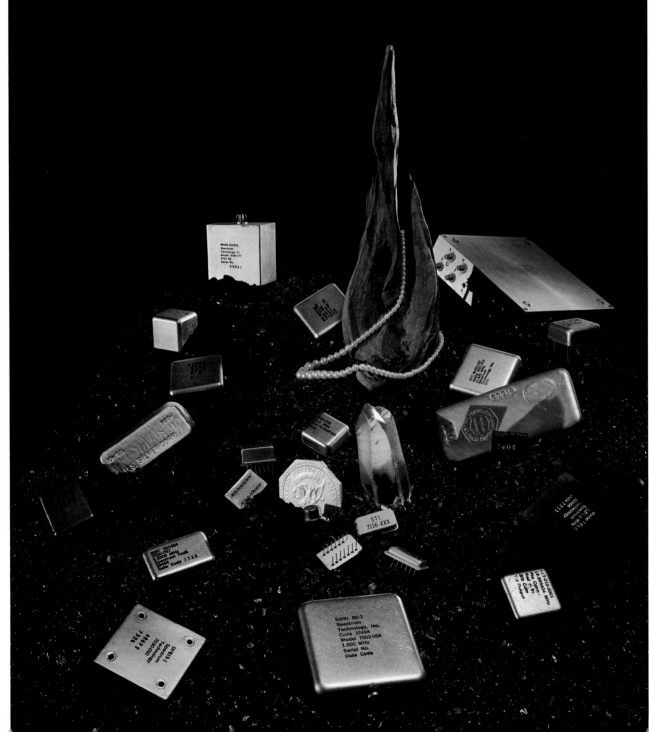

light. View the subject from several positions, high and low around the set, to find desirable highlight locations. Then place another light in exactly the position from which you observed the desirable highlights. This light will recreate the highlight exactly when viewed through the lens. The familiar principle is that the angle of incidence equals the angle of reflection. (Billiard players make good still-life photographers and vice versa.) When the subject has been highlighted in this way, the small spotlight can be removed from in front of the lens and the total effect checked on the ground glass. Some modification of these highlighting units will be necessary from the standpoint of intensity or character (sharp versus diffuse), but no change will be necessary in the placement.

3. *Establishing the Fill Light:* Fill-in illumination to provide adequate shadow detail can be supplied optionally by a diffuse floodlight, a reflector, or for smaller subjects, a mirror. The single most important requirement of a fill light is that it should cast no identifiable shadow of its own. This fault is most prevalent with floodlights and is generally solved by using the fill lights at a low angle—tabletop height—or by positioning it as close as possible to the lens.

The first thought that comes to the photographer considering the interplay between the fill light and the light or lights producing the brightest portion of the picture is the *lighting ratio*. It is necessary to establish a useful balance between the highlights and shadows so that the film can record detail in both. This useful lighting ratio is totally dependent upon the inherent *reflectance range of the subject.*

As an example, those tiny machined parts and diamonds against the blue background have perhaps automatically a 200:1 brightness range, even with the flattest of lightings. The photographer's chore here was to add more light to the dark areas and less light to the highlights so as to bring the total scene contrast down into the range of the photographic materials in use. With most color films, it means keeping within a 5-stop range if detail is desired in both the highlights and shadows. This is about a 32:1 relationship between meaningful highlights (not including specular diamond sparkles) and useful shadows. Any area

of the picture beyond this range will probably be rendered too dark or too light in the final photomechanical reproduction.

If the subject is primarily high-key, such as rolls of tissue and a yellow tulip, the scene reflection brightness range could be referred to as almost 1:1 (except the green leaves) with flat lighting. Here the photographer delicately boosted the range by directional lighting. If he had used a 32:1 lighting ratio, he would have had a full-range rendering—for better or worse.

If a photographer could have his way, he would have photographic equipment that could reproduce a scene just as the human eye sees it, stopping down for the highlights and opening up for the shadows. Then he could push a main light into place, add an accent highlight here and there, and make a picture with all of the depth and intensity that his eye beholds. But, the state of science being what it is, technical rules must be followed, and shadows have to be illuminated to produce what the eye knows is lurking there.

The portrait photographer generally resolves this problem in his studio by planting a semipermanent fill light on or near his lens axis. Thus, every shadow that the lens peeps into is automatically and uniformly lightened. He is then free to maneuver the main light around his subject to produce the particular modeling that most flatters the individual. If he maintains the proper distance for the main light relative to the fill light, he always has the same light ratio.

This is a most useful approach, and many a commercial subject is lighted in the same manner. Frequently, however, exceptions in technique must be made. Tight, close-in still-life settings usually prohibit having a light close enough to the lens axis to be effective, and any attempt to do this will produce a second set of shadows trailing behind the subject. This failing is particularly noticeable in product photographs when a tabletop setting is used. The still-life photographer must find new ways to fill his shadows. If he chooses to fill them all equally, a large diffuse light will work, creating almost unnoticeable new shadows. Relatively large bounce boards or curved white cardboard spinnakers flanking the front of the set can be of great value here. Or, he can fill the shadows from the actual shadow side of the set if

CONTINUED

Photographer:
FRANK J. CHIULLI
for Skelton Photography

**This handsome
monochromatic
photograph illustrates
how careful placement of
highlights and shadows,
alone, will delineate
shape and texture. The
simple lighting was a
single 750-watt spotlight,
softened with a
tracing-paper scrim. A
white card behind the
coffee pot and to the right
reflected back onto the
spout. Equipment: an 8 x
10 studio Deardorff
camera, 18-inch
Apo-Tessar lens,
EKTACHROME
Professional Film.**

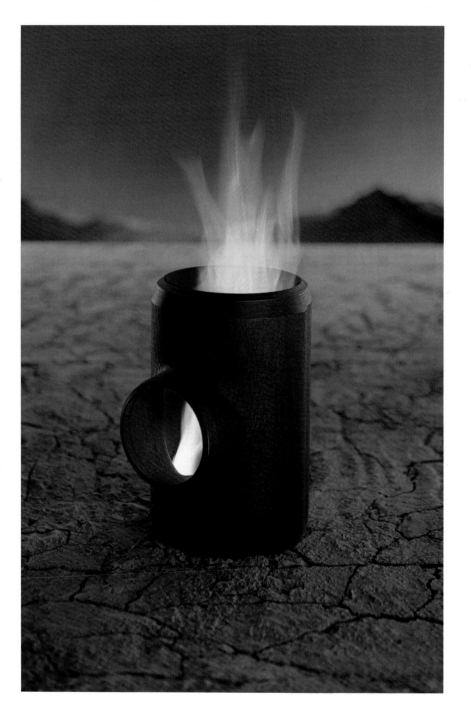

Photographer: JIM JOHNSON
Feldkamp-Malloy, Inc.,
Jack Brouwer/The Jaqua Company
for Taylor Forge

A softly lighted set, without a key light, becomes brighter toward the cardboard mountains on the horizon. The key light was provided by the flames in the pipe casting.

The simulated desert scene was created in the studio. The foreground was force-dried dirt to obtain the cracks. The mountains were sized-up with the camera in place, painted and lighted for mood, creating as much of a real-life situation as possible, which was the prerequisite. A hole had been cut in the 4 x 8-foot plywood sheet which held the cracked dirt. Over the hole we placed the casting and through it we shot the flame, created with propane gas and a homemade flame thrower. A 750-watt, orange-gelled spot, low to the left, picked up the dirt texture and rimmed the casting. A 150-watt small "inky" spot edge-lighted the casting from the right. Twenty feet behind, we placed the cardboard mountains, lighted with another 750-watt spotlight. Behind that, a dark blue paper swept across the far wall, lighted with two 2000-watt spots covered with orange gel. A total of about 35 feet of studio space was used in order to control the degree of soft focus necessary to simulate the great distance. Two exposures were made with the 12-inch lens: 2½ seconds for the set and ½ second for the flame, both at f/16.

The illustration was featured in industrial magazines.

Photographer: FRED ENGLISH
Hal Lawrence, Inc.
for Tempress Microelectronics

When the agency mentioned that they wanted a photograph of the Tempress scribing tools plus some real diamonds, I wasn't sure what problems I was getting into. The tools, made for the semi-conductor industry, have semiprecious industrial diamonds at their tips and are used to scribe silicon wafers containing microcircuits. The photo session proved to be a project, but one with an interesting result. The three smaller diamonds in the foreground had a wholesale value of approximately $15,000 and came to the studio complete with a guard who never left the room in the 4 hours that we spent setting up and shooting some variations. The three large "gems" are replicas of the world's largest diamonds, from a set that was available to jewelers some years ago. All these objects are sitting on a 32 x 60-inch piece of plate glass. About 2 feet below the glass is blue cellophane—we got a couple of rolls, crinkled it up, spread it out, and used spotlights directed at it to obtain the out-of-focus highlights in the background. Various small 150-watt spotlights with colored gels were used to highlight the tools and diamonds, plus some white light bounced from large white reflectors around the studio and from an 8 x 8-foot muslin reflector hung from the ceiling. Exposure was 15 seconds at f/32 on KODAK Color Negative Film, Type L, using an 8½-inch Caltar-S lens on the 4 x 5-inch view camera. A polarizing filter at the lens was used to reduce reflections from the glass.

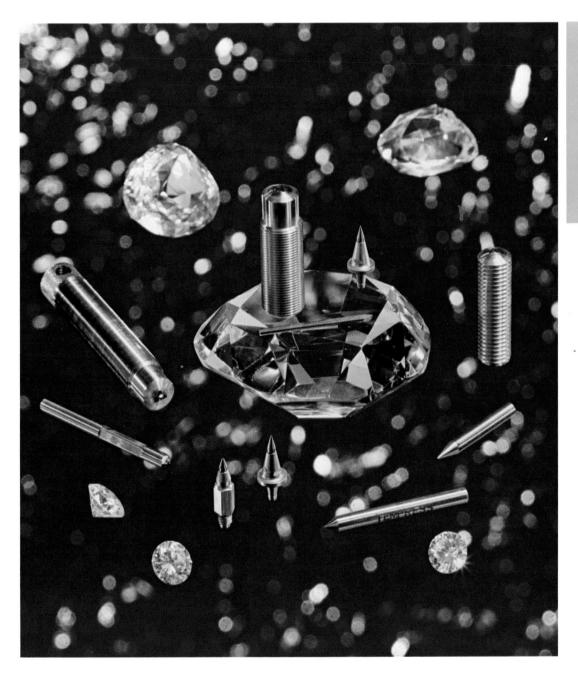

the light he uses for the job doesn't create noticeable new shadows. Large, diffuse light sources at close range, and at angles where the faint, soft-edged shadows are cast into unseen areas, can accomplish this.

Another approach to filling shadows is *selective lifting*. It is not always necessary to fill all shadows. Meaningless shadows, obtrusive shadows, ugly black puddles—these are the ones that need help.

Major spotlights with snoots as well as small mirrors can easily resolve these problems by throwing a small beam of light into each to lift them to the desired level.

Perhaps one of the most overlooked lighting instruments in small-object photography is the mirror. It has the advantage that it can be positioned where it would be physically impossible to situate a lighting unit. Nonhardening modeling clay makes an ideal nonskid-positioning medium for smaller mirrors. Black masking tape is used to cover parts of the mirror, thus making it into a reflector of any desired shape without actually cutting it. Mirrors are particularly useful in sets where the backlighting main source can be reflected into details on the front of the subject.

Every light used on the set has a purpose and should be playing a meaningful role in the creation of the final photograph. Above all, a dominant light source should prevail, without excessive competition from other light sources. Lights on a set should not compete with each other. If the addition of a new light creates a whole group of new problems, then it is time to turn off some switches and start over again. Simplest approaches are the most effective.

Lights on a set should harmonize with each other. If the dominant light is a spotlight, any obvious additional spotlighting is usually distracting. A more complementary light to use would be a soft diffuse fill light or local, crisp fill lights.

Accent lights are meant to contribute a little additional seasoning to the total effect. They should never dominate, but should be in keeping with the quality and direction of the main light source.

However, there are situations in which a nondominant light is used. Such light can be found in totally diffuse tent lighting and bounce lighting. Excellent for some subjects, it tends to create a

poster-like, flat graphic quality and is usually most effective when kept pure, without the distraction of nonharmonious direct light. The only additions necessary are a few highlights to contribute sparkle to the usually lackluster scene.

In dealing with unreal settings—pictures without a specific location such as catalog merchandising photographs—it is often desirable to make use of multidirectional lighting to bring out the objects on the set. Such lighting should still fall under the same rules—no multiple shadows, no obtrusive shadows or highlights, unequal intensities for each of the lights—so as to provide some degree of natural dominance and visual interest.

Light Ratio Versus Subject Brilliance

A total scene contrast is the most important element to be concerned with in lighting a set. Determining this permits the photographer to know how his film will respond to the scene. A subject with a 10:1 light-to-dark inherent reflectance will become a 10:1 scene with flat lighting; a 20:1 scene with 2:1 lighting; and a 50:1 scene with 5:1 lighting. The reflected-type exposure meter will directly indicate these relationships when the brightest diffuse highlight and the darkest detailed shadows are compared as to needed exposure. A two-stop difference would be a 4:1 total scene contrast; a 4-stop difference would be a 16:1 contrast. Most black-and-white film emulsions require, when developed to the proper contrast, no more than a 5- to 6-stop range if they are to reproduce detail in both highlights and shadows.

Simplified Light Ratios: Two lights identical in size, shape, and intensity can easily produce automatic ratios simply by using them at known distances. Keeping one as a main light and the other as a fill light near the camera axis, the following distances produce equivalent light ratios:

Main Light	Fill Light	Ratio
4′	5½′	3:1
4′	8′	5:1
5½′	8′	3:1
8′	16′	5:1
8′	11′	3:1
11′	16′	3:1

Black-and-White Versus Color Lighting Techniques: In black-and-white photography, the photographer has many ways of adjusting the final quality. He can control the light ratio and thus control the total scene contrast. By manipulating exposure and development, he can adjust the final negative range—the density difference between the highlights and the shadows. Such manipulation should be employed only when the subject brightness range is such that lighting alone cannot accomplish the desired final result. Usually, the best quality print is obtained from a negative that has been properly exposed for the shadow detail and developed to a proper density difference for the highlights. With most subjects, proper lighting alone can permit the photographer to render his setting effectively. Knowing the capability of film and paper combinations is a prerequisite to adjusting the scene contrast on the set.

In color photography, the photographer seldom has control over the contrast of the materials he is using. He is restricted to the one working gamma of the film and to the contrast of the printing paper. He must be thoroughly acquainted with what the film can record and with what the paper can print. With direct transparency materials, he must be experienced with what the film can record and produce, as well as how usable the transparencies will be when they must be reproduced by conventional graphic arts systems or printing procedures. With such knowledge, he can then proceed to adjust his scene brightness range accordingly. As a general rule, the brightest highlight detail in the scene should be no more than a 5-stop range from the shadows in which meaningful detail is desired. This all assumes that he places his exposure almost right in the middle. For a higher-key rendering, the usual tendency is to favor the slight overexposure; and for lower-key effects, to favor a slight underexposure.

Photographer: ALBERT KARP
for Push-Pin Studios

This photograph was done for a cookbook cover. The soft lighting was simple, consisting of two 1000-watt, 3200 K quartz lights on the left of the subject matter and one large reflector to the right. Getting the spray-painted objects to hold a pose was the problem. The mixer was kept upright by pushing a ½-inch dowel through the paper background and taping it to the underside of the handle. The mushroom was perched on the mixer with putty. The onion dangled on a bent paper clip. The lemon, attached to a hidden fork, balanced on the goblet. The nude olive stood on its own. The false colors were for shock value. A 4 x 5-inch camera was used with color negative film, Type L.

Many skills outside the range of photography are mustered in successfully executing a concept. That's what keeps a photographer constantly on his toes and makes it exciting to produce, over and over again for the first time, the one picture worth a thousand words.

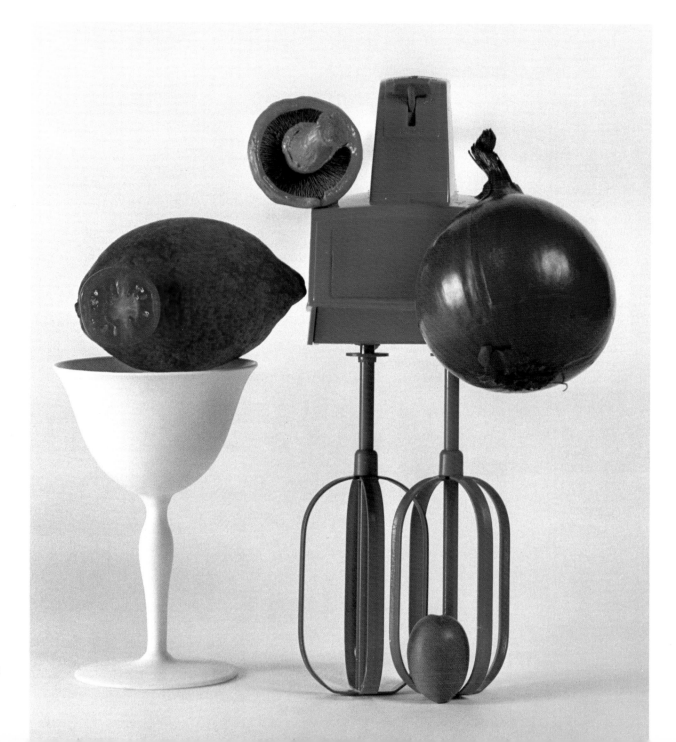

Photographer: SAM NOVAK
for Sears, Roebuck and Company

In this photograph, I worked to produce the illusion that the source of light for the photographs was the lamps themselves. I wanted the picture to be dramatic, but at the same time, to show the quality of the workmanship and materials used to make the product—the prime requisite for catalog illustrations. I used a 2000-watt Mole-Richardson spotlight on the left (with the Fresnel lens removed) to bounce light from an 8 x 10-foot white reflector. A 6 x 6-foot reflector at the left rear of the set shaded the background. On the right, another 8 x 10-foot white reflector provided a subtle fill light. The four lamps were equipped with household bulbs of various wattage and the intensity was balanced to the studio lighting by eye with a dimmer switch. The camera was an 8 x 10 Deardorff camera with a 19-inch Red Dot Artar lens set at f/45 at 15 seconds for EKTACHROME Professional Film.

What commercial photography means to me can be summed up in the following formula: A. Professionalism—to be competent in the commercial field; B. Creativity—to show originality and to be imaginative; C. Challenge—requiring the full use of one's abilities; D. Variety—having assignments that are different and require versatility; E. Reward—A + B + C + D = E.

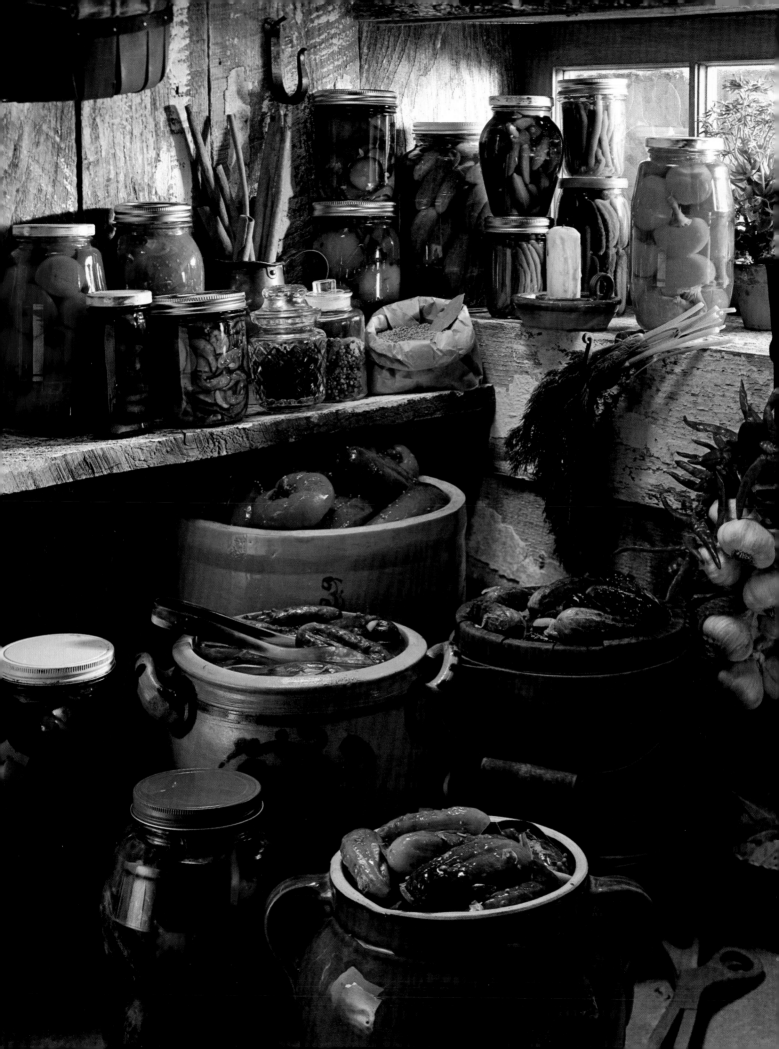

Photographer: BEN CALVO
for *Woman's Day*/C.B.S. Publications, Inc.

This illustration for an article on home pickling recipes for Woman's Day Magazine *posed a complicated lighting problem—to create, in the studio, the feeling of an ancient cellar in a country house. Authentic antique barn beams were fashioned into a corner set, with shelves positioned at different levels to give flexibility in composition. A standard basement sash window, purchased from a lumberyard, was set deep behind one wall to give the illusion of a low beam and to provide another shelf area. The glass was gently sprayed with dulling spray to make it look unwashed and at the same time to diffuse the potted plant placed behind it. Props were chosen with care to sustain the mood. The key light was a 750-watt spotlight directed through the window from "outside." A panel made of laminated fiber glass at the left diffused the light from a 650-watt quartz flood placed well back of it. Another 650-watt quartz flood, bounced off the ceiling from the back of the set, provided soft top-light to the containers. Mini spots were strategically placed from the top at the exact angle to highlight the pickles.*

The view camera was an 8 x 10 with a 12-inch lens. Exposure was 24 seconds at f/45 on EKTACHROME Professional Film.

**Photographer:
H. DAVID HARTMAN**

This photograph was conceived as a lighting exercise. I wanted to use two elegant objects, one visually beautiful and the other to arouse the senses. The nautilus shell is a beautiful work of nature and the perfume is a creation of man. I used the two to enhance one another.

The background is a roll of silver Mylar polyester film, satin finish. I used light and shadow to bring out the shape of the shell. The subject was sidelit by a bank of four electronic flash units with a diffuser in front. I used a small mirror to reflect light to the shell directly behind the bottle and black paper as a gobo so the rest of the shell would go to shadow.

The camera was an 8 x 10-inch Szabad camera with a 5 x 7-inch back and a 12-inch lens. Ascor speed-lights exposed EKTACHROME Professional Film, Daylight.

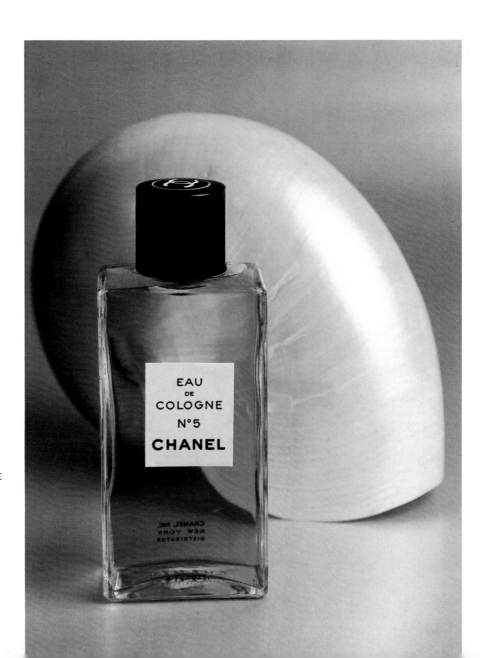

Photographer:
WILLIAM K. SLADCIK
for Northern Tissue

This transparency was made to introduce Northern Tissue's new line of Tulip Prints. The object was to give a light, airy feeling to the overall ad. The tulip, projecting out of the center of the roll, reemphasized the print pattern. High-key lighting was vital and very critical.

We were photographing white tissue on a white background and still trying to hold color in the greens and yellows as strongly and accurately as possible. One electronic flash unit, diffused with tissue paper, appropriately enough, from the right and a white reflector from the left did the job. On 8 x 10-inch EKTACHROME Professional Film, Daylight.

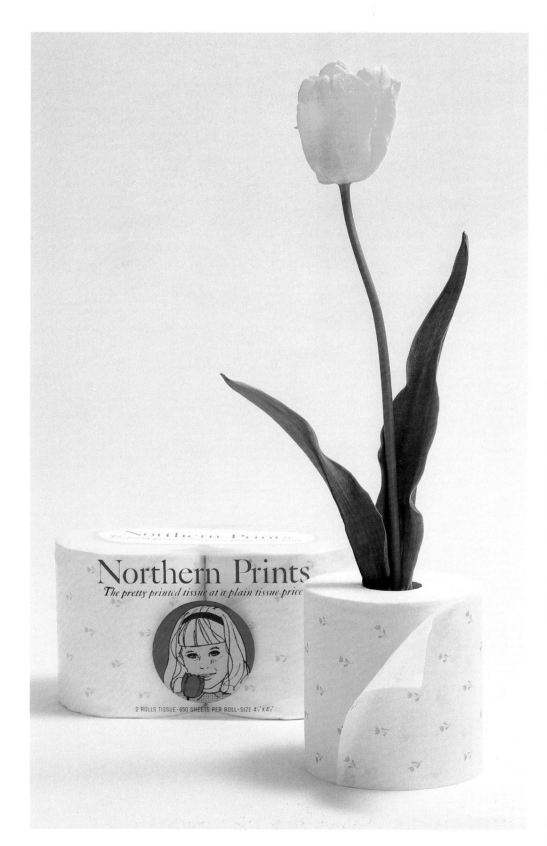

Photographer:
JIM JOHNSON
Feldkamp-Malloy, Inc.,
Jack Brouwer/
The Jaqua Company
for McGill Bearings

The product was depicted as being able to withstand industrial rust, dirt, and grime.

The bearing was lifted above the background area by means of a 14-inch strut fastened to the table and hidden behind the subject itself. The lighting consisted of three spots, all behind diffusion screens: a 250-watt light from the right for the face of the bearing, and two 150-watt miniature "inkies" front and rear, on the left. A strip of green gel was placed in front of the front screen and a strip of blue gel in front of the rear screen to add a touch of color to the inner and outer diameters of the bearing. The lighting, entirely through diffusion screens, lent itself to the shining surfaces, giving brilliant highlights, but still was soft enough not to overemphasize the dull and dirty background. That background was "enhanced" by the use of a cobweb machine and real dust. An 8 x 10-inch camera with a 14-inch lens stopped to f/45 and EKTACHROME Professional Film recorded the job.

SUBJECT SURFACE
DETERMINES LIGHTING

The texture, tone, and general surface characteristics of a subject almost automatically dictate modifications of basic lighting techniques. Thus, when an experienced photographer is handed a polished object to photograph, he begins immediately to think in terms of tenting. If the object has a matte, textured surface, he knows that undiffused spotlights are going to be required. Transparent and translucent objects should be lighted from the back. Dark objects require more intense light than light-colored objects.

Regard this seemingly innocent bowl of fruit. In that one porcelain container there rests a complete gamut of lighting problems.

Illustrated is a series of lightings to attempt to do justice to each different type of fruit in the bowl. The final solution is a compromise.

The important thing to realize is that no one lighting setup will be best for multiple subjects with different surface characteristics, even if they are similar in shape.

a. *One main light, from the left rear of the set, is effective for showing the translucent quality of the orange slice.*

b. *Add a soft reflected fill to that main light and see the beauty of the peach and orange.*

c. *Now, to the main light add a number of small spotlights from the front of the set—for those black grapes.*

d. *A complete change of lighting technique—to a tent—makes the white grapes come alive and helps the blue design on the bowl.*

e. *Finally, a bounce light from the right rear of the set becomes the most attractive lighting compromise, holding shape in the black grapes, detail in the orange slice, and giving flattering contour to the bowl, with enough shadow below to hold the composition to the table.*

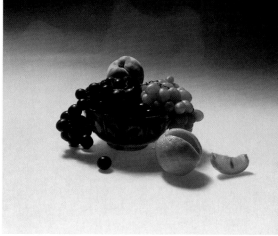

a.

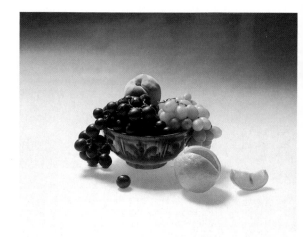

b.

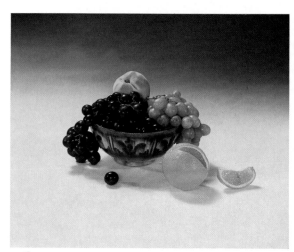

c.

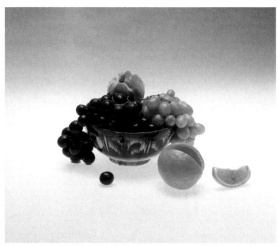

d.

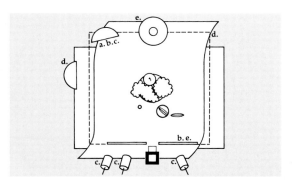

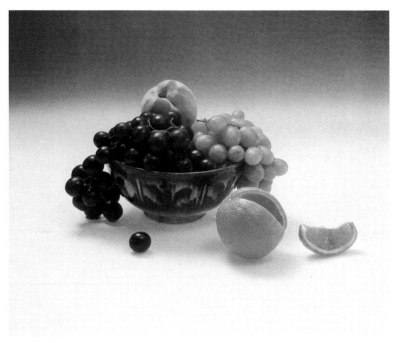

e.

Photographing
The Invisible

Of all the subject matter placed before the cameras of photographic illustrators, those that can be seen through or mirror their surroundings and those that transmit light easily cause by far the most problems. Because transparent and reflective objects, and translucent objects to a lesser degree, take on the characteristics of their surroundings, the photographer must not only concern himself with the objects before his lens, but he must also think about everything within 360 degrees of that object as well!

When you are lighting clear glassware, you are actually illuminating just the background behind the subject. The amount of light and its color will be assumed by the transparent subject, but in a distorted manner, depending on the shapes and convolutions of the subject itself.

The translucent subject takes upon itself the color of the background, if it is naturally colorless, but it also reflects portions of the foreground from its front surfaces.

Finally, the mirror surfaces of a reflective subject throw back at the camera all that is before them—lights, stands, camera lens, and sometimes an unintentional and distorted portrait of the photographer.

The illustrations, captions, and diagrams of this chapter explain a number of solutions to these problems.

Tenting

The technique of surrounding a subject with white reflecting surfaces is known as "tenting." Although the reflecting material generally used is white paper stretched over a light frame, an additional dimension can be obtained by constructing the tent from translucent plastic sheeting. By directing spotlights onto the plastic sheeting from the outside of the tent, a very diffuse lighting can be shed upon the subject inside and accents of color can be added by placing acetate gels over some of the lights. Strips of black paper taped to the inside of the tent will add necessary dark accents to completely reflecting subjects, thereby giving roundness and shape. Colored paper can be used to liven up a colorless subject. For specular light, cut a hole in the tent and shine a spotlight through.

A permanent tent can be constructed in such a way that it can be hoisted to the ceiling of the studio when not in use. Or, the entire studio can be made into a high-key set by painting the walls and ceilings with matte white paint. When other than high-key subjects are photographed, temporary walls and rolls of colored no-seam paper can be introduced. The remaining white ceiling will add soft, overhead fill light to any subject. This type of convertible studio is ideal for use with electronic flash units, whose light is bounced off the walls.

When you are photographing a reflective subject with a view camera, you can avoid the reflected image of the lens by using the rising front control for the lens board or by sliding the back board to its extreme position.

Spraying and Dulling for Reflection Control

The answer to control of difficult reflections in shiny objects can often be found in the use of matting spray or dulling compound rather than in tenting. The high gloss of the highlights in shiny metal objects with curved surfaces can be subdued by spraying the entire surface with the contents of a pressurized can of matting spray, available at hardware or art supply stores. Be careful, though, of indiscriminately spraying all types of shiny objects, since the spray may attack chemically some plastics or finishes. However, it is usually satisfactory for metal objects and can be wiped off easily with a cloth after the picture has been taken. Matting spray is also useful for diffusing the back of a glass of clear liquid in order to spread the backlighting evenly across the back surface.

Another way to dull or matte shiny objects is to use cosmetic eyeliner or pancake makeup. The makeup is applied with a camel's-hair brush wherever desired and in whatever quantity is necessary to control the highlights. The amount to be applied depends upon the surface texture of the subject. A brushed-metal surface needs but a slight amount of makeup, whereas a highly polished chromium surface would need a heavier application. Brush out and smooth the applied makeup carefully, using a lintless cloth as a final buffer so that the coating will be as even as possible and the application invisible from the camera. Still another material that is useful for reducing highlights, particularly on metal objects, is ordinary glazier's putty. Knead a quantity into a small ball and simply dab it onto the surface; then blend the area with a soft cloth. These techniques are all suitable for subduing reflections on plastic, glass, and leather subjects, as well as those of polished metal.

Exemplifying the title of this chapter, here are three striking photos. Surely the driest of all dry martinis, cold and clear; the sunniest of tequila sunrises, glowing with refreshment; and the enigma of a seemingly completely reflective sphere that turns black into white.

Photographer: FRED BURRELL

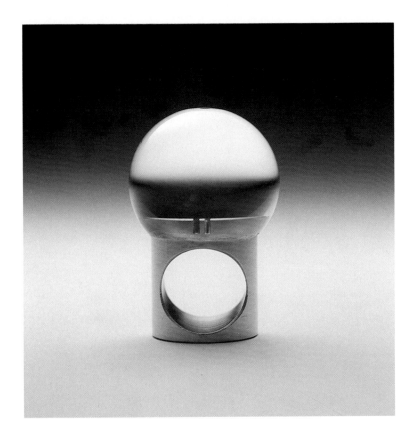

Photographer:
DIETER SCHMITZ
for Frau Magazine

Photographer: WILLIAM McCRACKEN
Gordon & Weiss Advertising Works
for John Dritz & Sons, Division of Scovill Industries

The assignment was to photograph the completely transparent box to show the ease of storing sewing items in the well-laid-out compartments as well as the ease of access to the two large hinged covers. The photograph was used on the cardboard container for the sewing box as a point-of-purchase attraction and as a black-and-white magazine advertisement.

The sewing box was placed on a glass tabletop covered with a sheet of black paper having a hole in it the exact size of the box. A 250-watt, 3200 K flood under the table highlighted the plastic box from below with light diffused by tissue paper. A 500-watt, 3200 K main light was placed high and to the right; a 250-watt flood filled from the left front. An 8 x 10-inch studio camera with a 14-inch Goerz Gotar lens exposed EKTACHROME *Professional Film.*

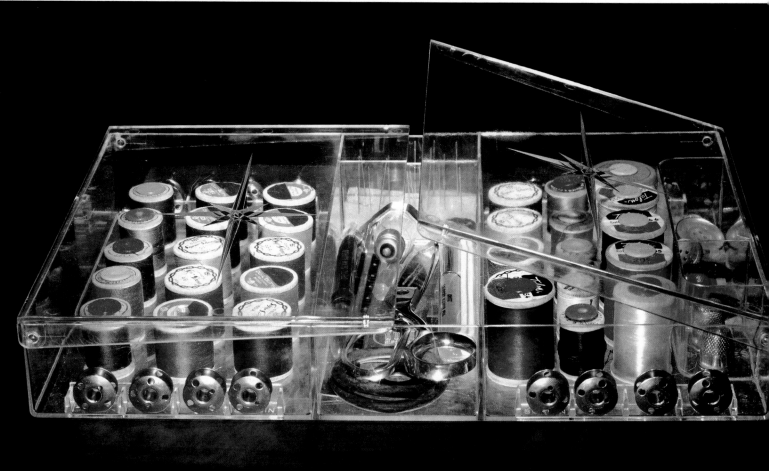

**Photographers: SAM KANTERMAN
and BILL VIOLA**
for Schenley Industries

A classic example of camera angle
changing the impression of subject size.
The glass is an ordinary martini cocktail
glass, but because the camera is viewing it
from below—an unusual point of view
for most people—the glass takes on
gigantic proportions.
　　The layers of natural products in
the glass are some of the ingredients
of gin: cassia bark, juniper berries,
coriander seed, orange or lemon peel,
anise seed, etc.
　　The simple lighting consisted of a
spotlight on the background to separate it
from the glass and a floodlight from the
left to light and give texture to the objects
within the glass. An 8 x 10-inch camera
with a 14-inch lens exposed
EKTACHROME Professional Film.

A "cordial" Christmas advertisement.
The lighting consisted of two spotlights
backlighting the drinks and a large,
soft, floodlight filling in from the right
of the 8 x 10 camera with a 12-inch Goerz
Dagor lens. On EKTACHROME
Professional Film.

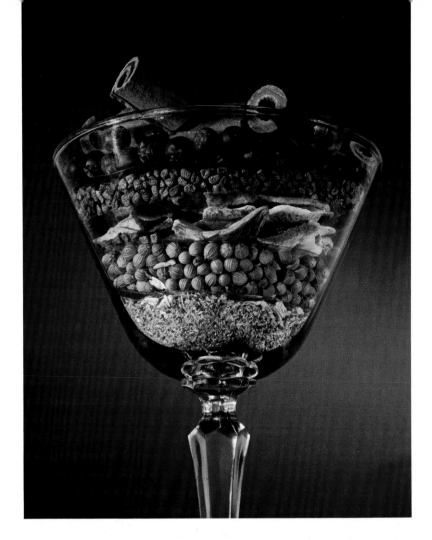

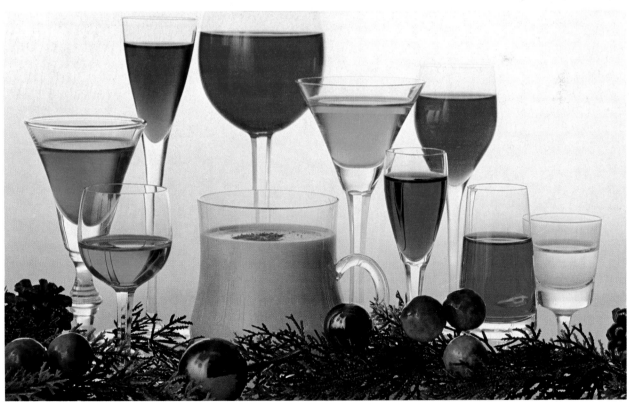

Photographer:
CHARLES WECKLER
Weckler's World
for DelMonte
Corporation

Around the globe, what better way to extol the health benefits of natural beverages than with beautiful children? In both of these lovely photos, the lighting brings out the products by taking advantage of their translucent quality, almost making the liquids light sources themselves.

This DelMonte pineapple-grapefruit juice advertisement was one of a series of four. The model, who is my daughter Rebecca, was posed in our living room window about midmorning. I used just the backlight from the window. Photographed on color negative film with a Hasselblad camera, 150 mm lens. The print for reproduction was on KODAK EKTACOLOR Paper.

Photographer: **ANTONI ALBA**
for M.M.L.B., Rania, Spain

All commercial photography should create a believable environment. To achieve this, all the elements of the real situation must be present, but not necessarily seen. For this photograph a complete kitchen was assembled. This allowed the young girl to actually feel the heat around her. 1000-watt quartz lights reflected off white screens were used for illumination. A Nikon 35 mm camera, 85 mm 1:1.8 lens and KODAK EKTACHROME Film were used.

Photographer: FRED BURRELL
for Coca-Cola International

**The indistinct mystery of translucency
itself engenders photographic ideas.**

*The model was placed behind a sheet of frosted acetate, which
formed the base and background for the bottle. The acetate was
sprayed with water to reveal the model's face more clearly and
to give a cool, wet appearance that would enhance the bottle of
Coca-Cola positioned in front of the acetate. A single floodlight
illuminated the set from behind the acetate screen.*

Photographer: WILLIAM McCRACKEN

**This macrophoto was simply lighted with a
small spotlight under the textured base
(formerly an office door window) and a
single spotlight from one side.**

*By using strong composition and lighting, an
attempt was made to suggest through the dried
natural foods around the perimeter, the strength
contained in the vitamin capsule.*

Photographer: FRED LYON
Botsford Ketchum, Inc.
for The Christian Brothers

Photographing transparent subjects on location is a most difficult assignment. The logistics for an expedition such as produced these wine advertisements is formidable. Then the difficulties of finding the exactly correct position in relation to the constantly moving main light source and arranging the surroundings so that nothing foreign— such as power lines or contrails in the sky—adds a jarring note to the picture, all put additional burden on the photographer's shoulders. These words from a master:

One of the variations shot for a Christian Brothers Sherry ad, this Kodachrome transparency made use of a Crosstar filter to accent the specular highlights. In keeping with the mellow moments associated with sherry sipping, the location, food, and flowers were keyed to yellow, gold, and brown tones. I prefer not too much direct sunlight on food (for psychological reasons), so I cast a foreground shadow with a translucent scrim and provided soft fill light with a large, slightly warm reflector just to the right of the camera. The lens was a 35 mm P. C. Nikkor.

Botsford Ketchum, Inc., the agency for The Christian Brothers' national ads, encourages me to experiment with creative approaches. They provide an unusually expert and enthusiastic support team, which consists of the art, the creative, and copy departments, but especially a superb food styling staff. Maggie Waldron, head genius, keyed all the props and food toward the magentas, accentuating the color of the wine and vine leaves. (See the long shot.) A large plastic scrim diffused the harsh direct vineyard sun, while small, soft reflectors (some of them magenta napkins) open up the shadows. A small piece of a mirror, hidden behind the bottle, provided the "see-through" associated with this refreshing light wine. The lens was a 50 mm Nikkor; the film, KODACHROME Film.

Photographer: RON KELLEY
for Lanello Reserves

The challenge here was to show the coin at an oblique angle, with little or no reflection, with the appearance of floating.

The coin was placed on a clear plate glass sheet, standing on edge, with a piece of white textured glass as the background. The floating effect was obtained by using a low camera angle, shooting up through the plate glass sheet. I made three separate exposures, using only one small spotlight per exposure to minimize stray light. The first exposure had sidelighting from an extreme angle with the light feathered forward to avoid reflections from the textured glass and illuminating only the embossed portion of the coin. No fill light was used, in order to keep the flat part of the coin dark. The color in the background was achieved by two separate exposures with the spotlights behind the textured glass. I used a green glass filter with one light source angle, and a blue glass filter with the light source from the opposite angle, thus achieving the purest color with no white light coming through the glass. An old 8-inch lens was used to expose 4 x 5-inch EKTACHROME Professional Film.

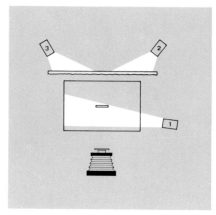

58

Photographer: BJORN WINTER
Jerry Peterson—Photography for Bertolini Seating

Products that contain reflective areas, such as this chrome and leather office chair, pose special lighting problems. Since each reflective surface must be faced by a reflector, the set becomes complicated.

This photograph was made on our high-key set using a combination of bounce light and soft lights. The color on the background was formed by the use of color gels over spotlights.

Photographer:
TED POBINER Studios Inc.
for Omega Watch Co.

The lighting for this shot consisted of two 1000-watt quartz lights bounced from white reflector cards on opposite sides of the set. A small spot, placed high, brought out the details in the metal. After the basic exposure was made, a second exposure, made through a star filter against a black board with pinholes in it, created the stars. The camera was an 8 x 10-inch Deardorff with a 14-inch lens. The film was EKTACHROME Professional Film.

This photograph was made for the Omega Watch Company as part of our regular service to them for their sales portfolios. We furnish most of Omega's photographic needs for brochures, mailers, sales photos, and black-and-white shots for use in magazine and newspaper advertising. We specialize in such photography for better jewelry manufacturers from coast to coast, and furnish them with transparencies, color negatives, and black-and-white prints, as well as quantity Ektacolor prints.

We feel that the commercial field has made tremendous advances in the past few years as a science, art, and communications medium. It is beyond question the finest tool any company can use to sell its products at minimal unit cost.

Photographer: ED NANO
Studio Associates, Inc.
for Moen/A Division of Stanadyne

An example of very selective focus, plus careful attention to the reflective qualities of the subject. Lighting consisted of four 1000-watt quartz floods bounced into a large curved reflector and placed so that they reflected from the face of the faucet. A white card picked up light for the side of the subject. The white ceiling contributed as well. The model in the blue coordinated background was illuminated by the main source and a 1000-watt quartz light bounced from an umbrella placed high to catch her hair.

**Photographer:
WALTER STORCK**
for TV Guide

This final illustration in the chapter on photographing the invisible is full of examples of all three types—transparent, translucent, and reflective . . . plus the mouth-watering goodness of beautifully prepared and photographed food. Enjoy!

To convey the texture and beauty of the fresh fruits and other ingredients to be dipped into the hot chocolate fondue, I used a bright spotlight from the right rear. To fill the pan with enough light to define the dark chocolate, I placed a diffused floodlight next to the camera. Finally, to add roundness, a white card reflector was placed to the left. This simple lighting gave the orange slices, strawberries, and marshmallows the translucent effect I wanted.

61

Food–
for Thought

Food processing constitutes one of the largest industries in the world. As an industry, it has one of the largest advertising budgets of them all. Although the major portion of the budget is spent on television, a goodly amount remains for both local and national still photographic illustration.

Those photographers specializing in food photography are a patient, knowledgeable group who work well with others. No other specialist needs the qualities of team leadership more, for not only is he working closely with an art director, but in most cases he is also directing the considerable talents of a home economist, a food stylist, a property master, and a photographic assistant to their utmost efforts. Since the objects before the camera are usually quite perishable, the team must work smoothly and efficiently. When the soufflé is ready, there is not a moment to lose! Or, there is nothing so deadly as a cold fried egg—and the camera seems to be able to tell.

The home economist is a highly trained artist and scientist in the field of food preparation. When a good home economist prepares a dish for the camera—and usually a number of identical models must be made—it is a mouth-watering treat. (Very few members of a food studio are underweight.) The home economist knows all of the special techniques for making foodstuffs photogenic and is an indispensable member of the team.

The food stylist knows foods and their accoutrements—dishes, tablecloths, silverware, and crystal as well as having a fine sense of style and knows what is presently in vogue. The stylist and the prop manager dress the set under the direction of the photographer and the art director. Usually the food product alone is not enough to make an illustration.

Over the years photographers and their staffs

Photographer: ALLEN A. SNOOK

In the following paragraphs I have put into quotes the words separation, form, texture, dimension, 3-D effect, etc. This is done in violation of proper writing form to highlight the important aspects to be remembered in still-life lighting.

The picture of the chocolate-chip cookies is selected to illustrate effective lighting of a food subject because it is virtually monochromatic. "Separation," "form," and "texture" are readily apparent without the complication of contrasting colors.

The product is fully realized in "dimension" or "3-D effect" through the placement of the main source of light. The only other source of light was a "bounce" card and it was purposely placed to barely invade the shadows.

The main light is never placed forward of the "3 o'clock" or "9 o'clock" position (with the subject at the center of the clock face and the camera at "6 o'clock"). Exceptions to this rule are so rare as to be almost nonexistent. The height of the light above the subject is as low as possible with the object of maximizing "texture."

The cookies are so placed as to give "variety of shapes" and to allow their cast shadows to function to the utmost for "3-D effect" and "separation."

Realism is the advantage photography has over artwork.

The reason someone is willing to pay a photographer to photograph his product is that he has learned that the photograph will portray his product in the most realistic way, with maximum impact, thereby helping him sell it by causing the potential buyer to practically taste, feel, or otherwise experience the product, even though it is only an image.

The "lighting ratio" here is perhaps a little extreme and would have to be considered carefully with the reproduction quality in mind.

In that regard, I don't believe in making it easy for printers, because it means flattening the lighting to the point where all the things I've been talking about are compromised.

have discovered shortcuts and look-alikes for items often pictured in food illustrations—substitutes for fragile creations that will not fade or sag under hot lights. Aerosol shaving cream stands in valiantly for whipped cream toppings on pies and puddings; white vinegar is more crystal-clear that tap water and, although slightly aromatic, will not form bubbles on the bottom and sides of a glass as it sits on the set for hours. On the other hand, a thin layer of clear rubber cement on the inside of a glass will maintain the bubbles in a sparkling beverage indefinitely. Crinkled cellophane, slightly out of focus, makes excellent crushed ice in iced tea. Plastic ice cubes have taken the place of glass ones—they float naturally. A tiny amount of table salt in beer before an exposure makes a beautiful head of foam. Kitchen Bouquet food coloring, usually used to make brown gravy, when mixed with water makes a coffee substitute that contains no oils to mottle the liquid surface. Thick steaks that are seared light brown under a very hot gas broiler and then artistically striped with a red-hot electric charcoal starter rod photograph with enormous appeal (and are rebroilable later).

All of these little tricks are harmless and only go to improve the incidental looks of a food photograph. They are perfectly permissible when the items so enhanced are not the specifically advertised products, but are background or peripheral items. However, other practices such as browning a turkey (the product) with wood stain and lacquer or representing the main subject of a photo—ice cream—with a mixture of soft soap and paint pigment, not only are deceitful and dishonest, but are against federal law.

The Federal Trade Commission Act of October 10, 1962, states in part: "It shall be unlawful for any person, partnership, or corporation to disseminate or cause to be disseminated any false advertisement—(1) by United States mails, or in commerce by any means, for the purpose of inducing, or which is likely to induce, directly or indirectly the purchase of food, drugs, devices, or cosmetics; or (2) by any means, for the purpose of inducing, or which is likely to induce directly or indirectly, the purchase in commerce of food, drugs, devices, or cosmetics." The Act sets the penalty: "Persons found guilty of the provisions (of the Act) shall, if the use of the commodity advertised may be injurious to health because of results from such use under conditions prescribed in the advertisement thereof, or under such conditions as are customary or unusual, or if violation is with intent to defraud or mislead, be guilty of a misdemeanor, and upon conviction shall be punished by a fine of not more than $5,000 or by imprisonment for not more than six months, or by both such fine or imprisonment." The Act also doubles the penalty for violations committed after the first conviction.

Today the consumer is in the driver's seat. Observe the letter of the law when photographing any product for advertising or promotional purposes. Don't fill the bottom of the soup bowl with clear glass marbles and then add the liquid and place the vegetables on top. Solve the problem legally; use a glass bowl, shoot from a low angle, and pour the steaming soup from a ladle. It makes a better illustration as well.

Finally, if there is any doubt at all regarding the use of any of these techniques, the safe and intelligent course to take is to consult legal counsel. Remember, *you* are responsible!

Photographer: WILLIAM FOTIADES
for Knorr Soups

I did a great deal of experimenting, using a 35 mm camera, to come up with an entirely new look and appeal in soup photography. I used boiling hot soup and a strong backlight for this national advertisement for Knorr Soups.

I wanted a totally natural feeling and lots of appetite appeal.

The back-light was a bare electronic flash tube, very low and close behind the bowl. A bank of electronic flash units provided fill light from above and right of the camera. The camera was an 8 x 10-inch Szabad with a commercial lens. Ascor Speedlights provided the illumination.

Photographer:
MITCH WEINSTOCK
for Kraft Foods

Adding that sparkle, like sugar
frosting, to the photograph of a
delicious dessert in not so very
difficult, if you know how.

The desserts were arranged
on a brown cloth. A 1000-watt
quartz flood behind a diffusion
screen from the left rear and a
1500-watt flood behind another
diffusion screen from the right
rear of the set effectively
illuminated the subjects. A
750-watt spotlight beside the
camera was focused on a silver
reflector above the rear of the
set out of camera range. This is
what caused those brilliant
highlights on the tops of the
glassware.

*After the picture was taken, I
marked the camera ground glass
where I wanted the stars to
coincide with the highlights.
On a large black card, I placed
Christmas tree lights exactly
where I had marked the highlights,
as I focused them on the ground
glass. Then I double-exposed the
film, using a star filter to obtain
this effect.*

Photographer: TOM FIRAK
for Kraft Foods

Consider the lowly baked bean. And one of the cleanest,
most definitive photographs of this mundane subject.
Placement of the single 1000-watt floodlight behind a
diffusion screen provides a soft, delineating light that
outlines every single bean in the foil pan, presents a large
highlight area for each bean, and gives an even
illumination to the can and the label as well. A large
white reflector to the right fills the shadows.

Also, consider the cleanliness of every one of those
beans and the placement of the pork chunks, which is the
handiwork of an excellent home economist.

Photographer: WALTER STORCK
Theodore R. Sills
for Family Natural Foods

The main light was a 1000-watt pan high overhead on the left and a 250-watt pan on the right side of the camera. A baby spotlight was used on each side of the set, far enough back to add roundness and texture to the bread.

The photographer who works primarily with an advertising agency must be able to follow a layout, be careful to leave enough space for copy, and use the proper lighting so that copy can be inserted into the picture. He must be aware of how the picture will be published; whether in a magazine, book, newspaper, poster, or whatever other medium. This is so he can select the proper lighting and focusing.

As a food photographer I face many problems in working with prepared recipes, making the results something the public will accept as easy to prepare and delicious to eat. Working with the food, I must study its body and texture so as to light it properly. The food should be prepared, arranged, and photographed as quickly as possible in order to maintain its fresh appearance.

Photographer: WALTER STORCK
Dudley, Anderson and Yutzy
for The Tuna Research Foundation

The picture was to have a bright Mediterranean look, with a stucco wall and a bright blue sky. A 1000-watt pan with diffuser was used from the right rear to make my main light look as if it were flooding through the window. A small fill at the camera softened shadows, and a 250-watt spotlight was shot across the set to give the greens and tuna a texture and clean color. Notice the variety of colors of green. Exact color balance is essential to make this distinction.

A good rule to follow when changing film emulsions is to make a test exposure as soon as possible! Do this while you are still using your old emulsion. This is the way to make the proper judgments of your filters. This also is true in using electronic flash. Poor color reproduction can ruin all the effort that the photographer has put into his work.

Photographer: BEN CALVO
for *Woman's Day*/C.B.S. Publications

Ideas on the presentation of fresh vegetables.

The problem was to create the look of farm-fresh produce, crisp from a summer's rain.

A bench top was made of pine boards rubbed with stain. Behind this was placed a sheet of shiny black plastic to pick up highlights and enable us to spray water freely without damaging the set. The vegetable drain basket was hung from a small boom for ease of placement. Fiberglass panels were placed at the sides and top of the set to diffuse and reflect the light from two 650-watt quartz lights situated high and to the left. An 8 x 10-inch view camera with a 12-inch lens gave an exposure of 15 seconds at f/32 on EKTACHROME Film. The photo of the melons was handled in the same manner as the vegetable picture, except here we substituted a rear-projection screen for the black plastic. Lighting was very much the same and again we used the boom, this time to support a scale pan. The background projection was deliberately underexposed to avoid conflict with the melons. The same camera, lens, exposure, and film were used for the main scene. The exposure for the projected image was 40 seconds at f/32. A black drape was drawn over the projection screen during the exposure for the melons.

Photographer: MITCH WEINSTOCK
for Kraft Foods

The spontaneous appearance of this fine food photograph is most deceiving. Notice, for instance, the few scattered crumbs below the French loaf. Not too many, not the same size, scattered in a careful path to the antique pewter platter. The bread is broken, not daintily but with muscle. The cheese is partially cut, but then broken to show firm texture. Finally, the rough board table and the man-size mug of beer, highlighted by means of a piece of silver foil hidden behind it, all make for a strongly masculine picture. We will bet that the cheese was an extra-sharp cheddar.

 The set was lighted with a 1000-watt quartz light behind a diffusion screen; black paper shielded the rear of the set from illumination. A small white card filled the shadows of the cheese bar and antique steel knife. A well-snooted baby spot provided highlight illumination for the silver foil behind the glass.

Photographer: FRANK J. CHIULLI
Skelton Photography
for Cling Peach Advisory Board

As the previous photograph was predominantly masculine, here is a strongly
feminine breakfast scene. Its primary use was as an editorial page illustration
for a trade magazine, but it was also used with the top half cropped out as a
5 x 8-inch recipe card.

The illumination was from a 4-foot square, 18-inch deep, light box
containing four 500-watt, 3200 K bulbs, and a front-frosted ¼-inch thick plastic
sheet as a diffuser. The unit was supported on a boom. Fill was provided by a
white card. An 8 by 10-inch camera with an 18-inch Apo Tessar lens exposed
EKTACHROME Professional Film.

Notice how similar props—rough boards and antique implements—
can be manipulated by lighting techniques to project feeling and gender.

Photographer: WALTER STORCK
for Jello Desserts—General Foods

Successfully breaking one of those rules:
"Never put food on a cold-colored background."

The product and the melon balls are of a very transparent nature, so great care in lighting balance and exposure was necessary. The main light was diffused to give a soft effect. A very soft fill from beside the camera was needed so that the subjects would hold their shape, and a tiny spotlight, also diffused, was placed to the left rear so as to add more roundness to the subject. An 8 x 10 Deardorff camera with a 14-inch lens was used.

In shooting editorial publicity pictures, a photographer must be open and free with his imagination. He must be able to create a mood and express a story through the use of his set and lighting. The "propping" of a picture is very important. Even here, the shape of the glass compote adds elegance.

In doing work of this nature, I find that the use of tungsten lights and EKTACHROME Film produces the effect I desire. The tungsten bulbs must be changed frequently in order to continue producing clean color, because they have a tendency to darken and turn warm. The shooting area around the set should be white to prevent the casting of unwanted color. Exposure time and bellows extension measurements must be exact.

STUDIO TIPS FROM AN EXPERT

Ben Calvo has been turning out beautiful photographs for the Woman's Day studio in New York City for many years. In that time he has devised a number of time-saving tools and practices which he presents here, with his best wishes:

a. *A good device for attaching small items to other equipment is this combination of two strong paper clamps with double strand of flexible copper wire soldered to their handles. This is very useful for attaching a sunshade to the camera face, foil reflectors to a light stand, or diffusers to lights.*

b. *Wooden cubes, 11½ inches on each side, made from ¾-inch lumber with handholds cut into several sides, are invaluable in many ways. We use them to stand on instead of a ladder, when the camera is just a little too high, or as a table base for low sets with a sheet of plywood as the tabletop. When photographing from a vertical position, set them under one end of a board being used as a photographic base. The tilt of the board will lessen the camera height necessary to achieve the proper perspective of the subject. We have three of these cubes and couldn't get by without them.*

c. *We use photographic enlarging paper cut to fit the camera film holder as an inexpensive method of checking composition and lighting. When you are used to looking at negatives, this method is better than using a positive print.*

d. *Two types of aluminum foil—dull silver and mirror surface—are useful as reflector material. We buy 30 x 40-inch sheets laminated to single-weight mounting board and cut them into many different sizes. Small pieces propped against a wooden block with putty can be placed behind bottles to reflect light through the liquid in them. The intensity of the highlight you are looking for will determine whether you use the shiny or the dull foil.*

e. *We have found three types of diffusion materials, purchased from hardware stores, very handy to have available:*

1. Aluminum wire screening, when placed over a light, reduces the intensity slightly without changing the character of the light. A piece of this wire over the lens will act as a star filter.

2. Spun glass, a single layer of which softens the light and shadows.

3. Syn-Skin, which is spun glass impregnated with clear plastic, makes excellent tenting material and gives more diffusion than spun glass alone.

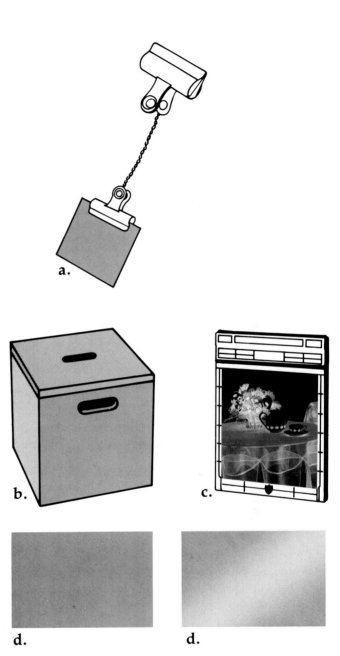

a.

b.

c.

d.

d.

e.1.

e.2.

e.3.

Outside–**Inside**

Here is a brief glimpse of a considerable photographic industry. It could be termed "architectural photography"—photographing the outside and inside of buildings.

Outside

The majestic exterior shots presented here appeared in annual reports, the preparation of which is a photographic specialty in itself. However, the photographing of the exterior of buildings need not be for such exotic purposes. Pictures of buildings are used extensively by real estate firms who have albums of homes and offices for their clients to leaf through. Municipal planning offices need photographs of whole areas of communities for study. And architectural firms proudly display photographs of their creations as well as plans and artists' renderings.

One pleasant aspect of such photography— you spend a great deal of time in the out-of-doors. And, your subject isn't likely to go wandering away.

Inside

Room interiors, room sets, and mock-ups of portions of rooms are used extensively in many phases of photo illustration. No item of furniture is more effectively presented than that photographed in an actual home—or an elaborate facsimile of one. Household products are easily recognized and accepted when photographed being used in their natural environment—kitchen, bathroom, etc.

In most cases, room sets in the studio are preferable to the actual thing. Low ceilings, cramped quarters, and no place to put the lights make shooting on location a trying experience. Studios with high overhead space are a blessing. Wall flats can be positioned, painted or papered, and furnished quickly; then easily lighted from overhead. However, there are occasions when it is mandatory that you travel to a room location to photograph something that cannot be brought to you.

Here is a basic list that can be of great value to a photo illustrator planning such a location shot:

Case No. 1. Camera equipment, including cameras, lenses, lens hoods, filters, focusing cloths, magnifiers, cable releases, exposure meters, notebook pencils, grease pencils, model releases.

Case No. 2. Film holders, changing bag.

Case No. 3. (Film cooler): film, extra batteries (for camera, exposure meters, flash or electronic-flash units), waterproof coolant container.

Case No. 4. Lights, stands, reflectors, umbrellas, scrims, tripods.

Case No. 5. First-aid kit, tool kit, accessory kit.

Tool kit. Hammer, assorted nails, small saw, screwdriver set, pliers, tweezers, spring clamps, matte knife and blades, single-edge razor blades, scissors, staple gun and staples, tape measure.

Accessory kit. Assorted wire, cord, string, thread, fishline; black masking tape, gaffer tape, transparent tape; florist's putty; dulling spray; assorted cements, fuses (house and electronic equipment); clear glass sheets and petroleum jelly; small brushes; assorted needles, pins, tacks; aluminum foil; plastic foil; tracing paper; hand cleaner tissues, facial tissues, paper towels; household lubricating oil; fine sandpaper; lighter fluid.

Note: Cases should be crushproof, water-resistant, lockable, and prominently labeled.

Photographer: FRED ENGLISH
for General Electric Co.—A&SPO

TVA's Brown's Ferry Nuclear Generating Plant is near Decatur, Alabama, and this scene was taken on a photo trip to picture nuclear plants and future sites. Although this plant was less than one third complete when we were there, we were fortunate that the office building had been finished and the exterior of the plant looked finished. I had taken several different angles during the daylight hours, but decided to try a day-night shot, for a more dramatic effect. I did not use two exposures on this view; rather, I took a series of exposures (negatives) as the last daylight was fading to get the one with the best twilight-to-artificial light balance. Only one light was added to the scene, a 500-watt floodlight directed at the name on the front of the plant.

The cooperation of the plant maintenance and security departments was necessary to adjust the window blinds and to get the lights all turned on in the office building. (Someone kept trying to save electricity in the hour or so that I took to set up and shoot this view.) I used a 135 mm Symmar lens on a 4 x 5-inch view camera, with the appropriate exposure time of 3 seconds at f/16 on daylight-type color negative film. Exposure determination was by experience and was checked by black-and-white test shots made with a Polaroid camera, as are 90 percent of my photos. The black-and-white print provides not only an exposure check for me, but a composition check for the art director as well.

Mixed light sources? Crossovers from long exposures on daylight-type film? Fortunately, with this kind of subject material, it doesn't matter.

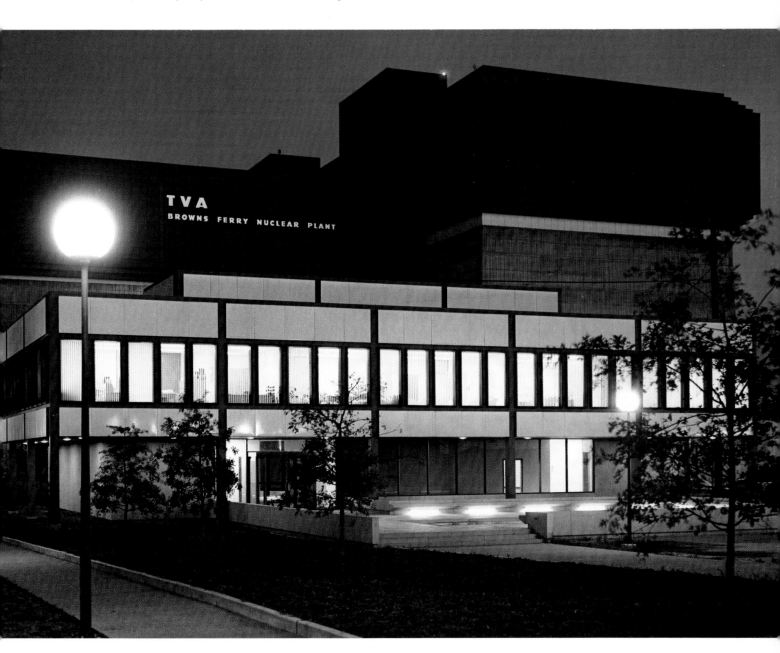

Fluorescent Illumination

At times, it is impossible for the photographer to control the lighting on a location set completely. When broad areas are lighted by fluorescent lamps, the only thing to do may be to conform to what exists rather than to redo the illumination completely. It is better to convert completely to one type of illumination than to mix two or more incompatible types of light. The inevitable result of mixed lighting is bizarre renditions of cross-colored highlights and midtones that are impossible to correct when the photograph is reproduced.

Scenes illuminated by fluorescent light usually appear pleasing and natural to the eye. Color photographs of the same scenes often have an overall color cast that is not at all what we remember. Fluorescent lamps emit visible radiation that is unlike that of most other light sources in that it consists of an incomplete spectrum. Most commercial fluorescent lamps emit very little red light but large amounts of blue and green light, as well as an unusual amount of ultraviolet radiation.

The most common types of fluorescent lamps are labeled standard cool white, deluxe cool white, standard warm white, deluxe warm white, white, and daylight. (There are a number of fluorescent tubes manufactured expressly for viewing color. They conform to the ANSI standards for viewing color photographs for reproduction. See page 104.)

The only practical way of overcoming the deficiencies of fluorescent lamps as a light source for color photography is by the use of color compensating filters *and* by testing each setup. Precise information concerning filters for specific types of fluorescent lamps is impossible to attain because the lamps change according to how long they have been on, how long they have been in use, how clean their surface is, and even how much voltage is being supplied.

Photographer: FRED ENGLISH
for General Electric Company—A&SPO

This photo is of a giant nuclear power generation steam suppression system that is used in the event of a "blow down" situation (the venting of excess reactor steam). It holds more than 1 million gallons of water and is constructed around the base of the reactor, deep underground. The facility was still very much under construction when we visited it, and it took some cleaning up of ropes, ladders, tools, etc, before it was ready to be photographed. I can best describe the shape of the Torus as a huge doughnut and we found it lighted with a few 100-watt bare bulbs on the catwalk, halfway up the tube. It was a very dark place.

The photograph was made during a 2-week tour and we had anticipated the need for lighting. We shipped 2800 watt-seconds of strobes ahead to this plant, but I could have used two or three times that much on this photo. Two power supplies were placed on the catwalk. A 2000 watt-second pack is hidden in the upper left corner of the photo, where two flash heads were bounced off the top of the tube at that catwalk level. A third flash head, connected to that pack by extension cords, was placed behind the steel reinforcing section in the right foreground on the floor and directed at the men.

The second power pack (800 watt-seconds) was located farther along the catwalk to the right, with one flash head also bouncing off the top of the tube. Both of these ac-power supplies were equipped with slave trip units and set off by a small 60 watt-second portable strobe held near the camera. The portable strobe also served to direct a small amount of light to the dark top-center area.

Using 4 x 5-inch color negative film, two 1-second exposures were made with the 75 mm, f/8 Super Angulon lens at its widest setting. The men were cautioned to hold their positions between exposures while the power packs were recharging. The 1-second exposures were used with strobe so that the existing bare light bulbs would register.

Photographer: TOM CARROLL
for William L. Pereira Associates

The subject of the oblique aerial photograph is the Los Angeles County Museum of Art and was done for William L. Pereira Associates, the architects. This is one of a series taken on a beautifully clear day. I try to group several accounts together when working in an area by helicopter. This day it was those whose interests lay on Wilshire Boulevard. I used a Nikon camera with a 55 mm Micro Nikkor lens and skylight filter. The exposure was 1/500 second at f/5.6 to f/8 by the meter on KODAK EKTACHROME-X Film, processed normally.

Books on aerial photography mention vibration in helicopters and they talk about hovering. If the helicopter is kept in a slight forward motion, you can shoot at almost any shutter speed without vibration.

Photographer: TOM CARROLL
for Texaco, Inc.

Making photographic illustrations in the out-of-doors is not for the impatient. Waiting is sometimes as important as making the correct exposure.

This is the final shot in an illustrative series on lighthouses, a disappearing architectural form, for Texaco. The exposure was by meter and bracketed 1 stop either side of the reading: ½ second at f/5.6 (the optimum opening for the lens). The exposures had to be synchronized with the rotation of the light in order to maximize the lighthouse effect. A CC30M filter over the lens enhanced the sunset color in the sky.

Below right: This is an earlier shot, taken while we were waiting for the magic moment when the sunset fades and dusk comes alive, a time that lives only about 2 minutes. Although foreground detail in the lighthouse subject is more visible, that's not what I was looking for. I wanted the mood of the moment, not detail. Both photographs are on EKTACHROME Film.

Photographer: ARNOLD DeLCARLO

**The "California look" in home building is brought out
in these interior shots, which integrate daylight backgrounds.**

*Both of these photographs were done for home builders as publicity in California
publications. They were taken with a 4 x 5-inch Synar camera and a 90 mm Schneider
Super Angulon lens. The lighting consisted of two Norman electronic flash heads,
without reflectors; one at 750 watt-seconds, the other at 500 watt-seconds. In order to
balance to the daylighted areas, both were exposed at 1/30 second at f/11.*

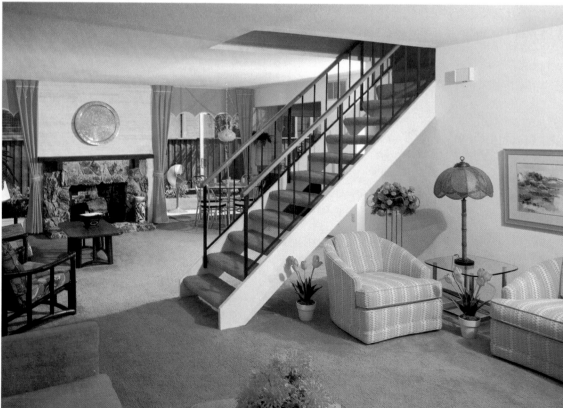

Photographer: JERRY PETERSON
for Stephen Edwards Furniture Manufacturing Co.

This photograph demonstrates what I call our "poor man's projection system." The only thing used to make the background of the city behind this room set is a KODAK CAROUSEL Projector. We left an opening in the background flats to form a window that showed the white studio wall. Then black paper was put over the white wall. The set was lit and care was taken that the light didn't spill onto the black paper. We placed the model low in the set so that her head appeared against the sofa, not in the black-paper area. We exposed all our film: three transparencies, two color negatives, and two black-and-white negatives. Then we took down the black paper, turned off the set lights, turned on the projector, refocused, and re-exposed all the film. The exposure on the basic set started at about 10 seconds at f/45; for the projection, about 75 seconds at f/8.

What appears to be a column of the apartment building in the background is actually part of the Griffith Park Planetarium, where the night photograph was made.

**Photographer:
BJORN WINTER**
Jerry Peterson—
Photography
for Lincoln Furniture
Manufacturing Co.

*Here we have taken
advantage of the
availability of one product
to help show off the
richness of another. We had
photographed the billiard
table for a client; before it
was removed from the set,
we put up a false wall,
placed the sofa and props,
and made this shot. The
wall behind the sofa is
supported by a stepladder,
as it is almost in the middle
of the studio.*

**Photographer:
BJORN WINTER**
Jerry Peterson—
Photography
for Cervitor Kitchens

*This photograph was made
for the manufacturer of the
kitchen unit, Cervitor
Kitchens. It carries the idea
that the cabinet will fit into
a living-room setting even
though it contains a kitchen
unit. It is a valuable idea
for small apartments.
Again, we used an existing
set for the background and
put up a false wall, right on
top of the rug.*

Photographer: BJORN WINTER
Jerry Peterson—Photography

Here is an overall view of our studio, one of the largest home-furnishings studios in the West. It is large enough for five room settings at one time. All interior walls are movable and the area in back can be opened to form a window. The high cantilevered roof gives us more than enough room to place lights above the set walls and to photograph from very high angles. The floor space is ample for the use of large-format cameras and the many lighting units necessary for doing the complicated lighting arrangements needed in this type of illustration.

Photographer: ED NANO
Studio Associates, Inc.
for Vistron Corp.

Here is an excellent example of the magic of studio illusion. For the cover of an Oxco Household Brush Catalog, two wall flats were braced at right angles and wallpapered with antique flocked paper. The antique furniture and props were placed on a floor that had also been papered with flowered wallpaper, to simulate an old-fashioned rug.

 The lighting consisted of one 12,800 watt-second electronic flash unit placed high to the left and bounced from a curved 12-foot high reflector, whose curve shape was 1/5 that of the circumference of an 18-foot circle. A second similar curved reflector filled from the right. An 8 x 10-inch camera with a 19-inch lens captured this illustration, whose caption was "The New Line Reflecting Old-Fashioned Value."

Photographers:
GRIGNON STUDIOS

This is really a modification of an assignment. We liked the set well enough to shoot this picture as a sample only. The assignment had been for an illustration for the box to hold the electric blanket, and had additional area on the right for copy.

Because of the pastel colors selected for this bedroom, the photograph was executed with "soft lighting." Most lamps were diffused and an open reflection-type of light source used.

Photographers:
GRIGNON STUDIOS
for Homemaker
Industries, Inc.

This illustration was executed for the bedspread manufacturer's catalog and display sheet packaged with each spread. The purchaser sees a reproduction of this transparency on the packaged spread in the store.

There were two basic requirements to be satisfied in this photo. First was to show the quilting and to get the effect that it was deep. This was accomplished by using direct light from a very low angle across the top of the spread—with great care—to be sure that it was even from one side to the other. The second goal was to show the pattern and color clearly. This was achieved by using a softer lighting on the front drop of the spread. Here the quilting was sacrificed to make sure the pattern and color were reproduced accurately.

Photographer: GRIGNON STUDIOS
for Kroehler Manufacturing

In a huge studio in The American Mart on Lakeshore Drive in Chicago, some of the most complex photographs in the world are made to illustrate fine furniture. Literally hundreds of individual spot and flood lamps are used to illuminate every tuft and tassel and detail of these sets. Lighting diagrams would be impossibly complicated, so enjoy the photographs for what they are—the finest of photographic advertising illustrations.

A book could be written on this photo alone. It has been called the best furniture photograph ever done—not by Grignon or our customer, but by people within the furniture industry. The set, a re-creation of an English pub, had a number of uses. With live models, it made a national ad; as a still-life, it was used in promotional material and sales literature.

The lighting was, of course, very complex, but let it be understood that each upholstered piece was handled as a separate entity. Each piece was lighted to emphasize the pillow back by creating the shadow below the headrest. Then the secondary lighting followed to build each surface in relationship to the level that the main light established. The chair in the foreground was allowed to go a little darker in tone to help emphasize the two main pieces. The rest of the set was lighted more as a display area, so as not to distract from the main subjects.

In general, we have long believed that in commercial photography it behooves the photographer to pay close attention to the subject and not let the balance of the photograph obscure or detract from the product being photographed. This does not mean in any way that the photograph will be gross or unattractive. Too often photographers take the position that because a client insists that his product be shown clearly, he relegates the photographer to the position of mechanic, simply recording an image on film. We violently disagree! The talented and successful photographer can make an attractive picture—that can stand alone—and also show the product to its best advantage or satisfy other commercial necessities of the illustration.

Photographer: STEVE BERMAN
for Monarch Carpets

Here, on a grand scale, on a movie sound stage, are two examples of massive product photography. For a MONARCH Rug Catalog, these are but two of many such whole carpet illustrations echoing past cinema glories. Notice that most of the lighting equipment is in the picture. The photographer's tongue was in his cheek. Those Hollywood sets are NOT dead!

Making It In The Commercial World

In a publication concerned mainly with the *techniques* of commercial photography, it is also appropriate to suggest ways of earning a better living by practicing the trade of commercial photographer. In the not-so-distant past the photographer was faced with the formidable difficulties posed by slow lenses, low emulsion speed, and hand processing. The actual taking and making of a photograph was time-consuming. How different things are today. Sensitive emulsions; computer-formulated, extremely fast lenses; excellent color films; and immensely sophisticated processing and printing services now combine to leave the photographer virtually free to devote all his energies to pleasing his clients. *And to building his list of clients.* Compared with the past, he hardly needs to worry about production techniques and the limitations of his materials.

This freedom from technical concerns should allow the modern commercial photographer to seek new business continually . . . not merely welcoming any new business that chances to come in through the studio door, but making constructive plans to *create* new business. To make people really want to buy his product. If you are going to get more people to buy from you, you will first have to persuade them that what you have to offer is of some tangible value to them. A commercial photograph is only valuable to the business world if it achieves something—if it communicates something that cannot be put into words, if it *sells* something. A portrait can be sold only as a personal record with lasting value. On the other hand, photographs of objects and scenes can be sold not only as records but as a means to increase business or as valuable art objects in themselves. This emphasis on the value of photographs to potential clients will be vital to the success of your photographic business in the future. If business conditions become more difficult, clients will want only those products whose value they can instantly recognize.

Every businessman in your community is a potential client. Study your local businesses. Decide how photography will help each one increase sales and income. The butcher could use large color photos of juicy steaks broiling on an open grill to increase the appeal of his product. The baker needs a complete color catalog of the many artistically decorated confections that he creates, as does the candlestick maker for his many beautifully sandcast works of art. Banks purchase appropriate landscape photographs for use on checks. So do funeral homes—for mural decorations. Building contractors are proud of their work and buy pictures. Printers are always looking for little black-and-white shots to use as chapter decorations. And so it goes, with every business establishment in town. Of course, be *very* attentive to any advertising agencies or art services.

Local industries, large and small, are fruitful fields for the enterprising commercial photographer. Those without an in-house photographic department are wide open. Even companies employing full-time photographers can occasionally use the services of another competent man. However, in such cases, it is important to approach through the friendship of the staff man.

The following checklist is designed to assist in evaluating photographic usage throughout a manufacturing company. Photography finds its legitimate place in the corporate scheme of things where it offers solutions to business problems that are superior from a cost-effectiveness standpoint to any alternative method. The aggressive photographer not only looks for and suggests to management new photographically based services that will meet these cost-effectiveness criteria, but constantly reexamines services currently offered to make sure they continue to represent the best and most productive methods of getting the job done.

ADMINISTRATION/MANAGEMENT

Annual reports
Construction progress reports
Control charts
Data distribution
 (micropublishing)
Data storage and retrieval
 (microfilming)
Decor (use of photos in interior
 design and decorating)
Executive briefs
Forms printing
Insurance documentation
Interior decoration reports
Inventory
Office layout
Office methods studies
 (time-lapse movies)
Offset duplication/printing
Organization charts
Plant site surveys
Purchase schedules
Stock prospectus
Traffic surveys

ADVERTISING/PROMOTION

Ad illustration
Catalog illustration
Dealer/customer publications
Dealer/customer seminars
Direct mail
Displays
 (for trade shows and lobbies)
Duplicate layouts
Exhibit guides
Incentive programs
Instruction manuals
Marketing publications
Packaging
Product and market brochures
Product literature
Promotional films
Television commercials
Trade shows

DISTRIBUTION

Damage records
Damaged shipment records
Flow layouts
Inventory control
Loading procedure data
Materials-handling studies
Packing and loading records
Packing guides
Record preservation
Traffic studies

INDUSTRIAL RELATIONS

Accident reports
Continuing education
Employee publications
Employee training
Health records
Identification photos
Medical pictures
Medical radiographs
Orientation presentations
Personnel recognition
Personnel records
Posters
Safety training

PLANT ENGINEERING-MAINTENANCE

Aerial survey of sites
Construction progress reports
Field exhibit reports
Industrial engineering studies
Infrared heat studies
Machine setup movies
Method analyses
Periodic inspection reports
Piping and wiring layouts
Plant layouts
Training media

CONTINUED

PLANT SECURITY

Identification cards
Infrared detection
Photo sentries
Surveillance

PRODUCT DESIGN/DEVELOPMENT

Consumer testing
Documentation of test setups
Field test reports
Instrument readings recording
Motor studies
Oscillography
Patent documentation
Performance studies
Pilot model photos
Proposals to management
Schlieren photography
Styling analysis
Wear and stress studies

PRODUCTION

Assembly instructions,
 chemical milling of parts,
 circuits and microcircuits
Masters for product decoration
Method studies and standardization
Nameplates or identification plates
Photodrawings
Process standardization
Reticles for optical devices
Shadowgraphs
Silk-screen masters
Templates
Time studies
Tool room reference—inventory
Work methods

PUBLIC RELATIONS

Annual reports
Corporate films
Personnel biographies
Publicity pictures
Stockholder reports
Television film clips

PURCHASING

Damaged-material pictures
Duplicate engineering prints

RESEARCH

Autoradiography
Bubble chamber studies
Electron diffractions
Electron microscopy
Flow studies
High-speed motion studies
Instrument trace recordings
Metallography
Microphotography
Microradiography
Nuclear photography
Photomacrography
Photomicrography
Reports
Seismography
Spectrography
Stereoscopy
X-ray diffraction studies
X-ray movies

SERVICE

Failure studies
Installation photos
Line art from photographs
Manuals
Parts lists
Training aids

TESTING AND QUALITY CONTROL

High-speed photography
Metallography
Oscillography
Performance records
Photomicrography
Radiography
Reports
Standards library
Test setups

SALES

Catalog illustrations
Equipment demonstration
Field estimates
Newsletters
Photo calling cards
Product portfolio
Product proposals
Sales force/dealer training
Sales meetings
Sales presentations
Sales reports
Specification sheets

Not all of these headings
can be accomplished by you
as a commercial photographer,
but the possibilities for your
doing business with manufacturers
are enormous.

BANK OF AMERICA

_____ 19 ___

PAY TO THE ORDER OF _____ $ _____

_____ DOLLARS

Follow This Crop!

BANK OF AMERICA

PAY TO THE ORDER OF

$

DOLLARS

Follow this crap!

Photographer: CHARLES WECKLER
Weckler's World, Gray Advertising Inc., LA
for Bank of America

*These landscape photographs for Bank of America checks were
all done with a Hasselblad camera with an 80 mm lens on
CPS120 film. A mask of the check format was taped onto the
ground glass for positioning of the image in relation to the
type. Most situations were recorded early in the morning or at
sunset. EKTACOLOR Paper prints were made to scale for
presentation and another set of prints was used for reproduction.*

Photographer: WILLIAM McCRACKEN
for Regina Services Corporation

During a period of slow economic growth, the photographer realized that most of his calls to the usual sources of business were being met with the response: "Things are very quiet just now." This seemed like a good time to use the Classified Telephone Directory, not as a buyer but as a source of photographic clients. Perhaps a new area could be tapped. In this way, the printing industry was approached and one particular call produced results. The printer had a contact in the airport construction field who wanted a brochure done on recently completed projects. At that point he did not have a photographer. After negotiations the locations were photographed and the brochure designed and printed. The builder was so pleased with the job that sometime later he

commissioned another company brochure to be produced by the same team. A lasting relationship has been established between the printer and the photographer, and they have jointly produced a number of catalogs and brochures for the industry.

These two photographs, the interior of the TWA Ambassador's Club and the lobby of the Alitalia Airlines Terminal at Kennedy International Airport in New York, were shot with a Brooks-Plaubel Veriwide 100 camera, a 47 mm Schneider Super Angulon lens, in a 2¼ by 3½-inch format. The lens has a viewing angle of 100 degrees. The film was KODAK PLUS-X Pan Professional Film. The photographs were made for the most part with existing light with some help from two 500-watt floods to fill in the shadows a little.

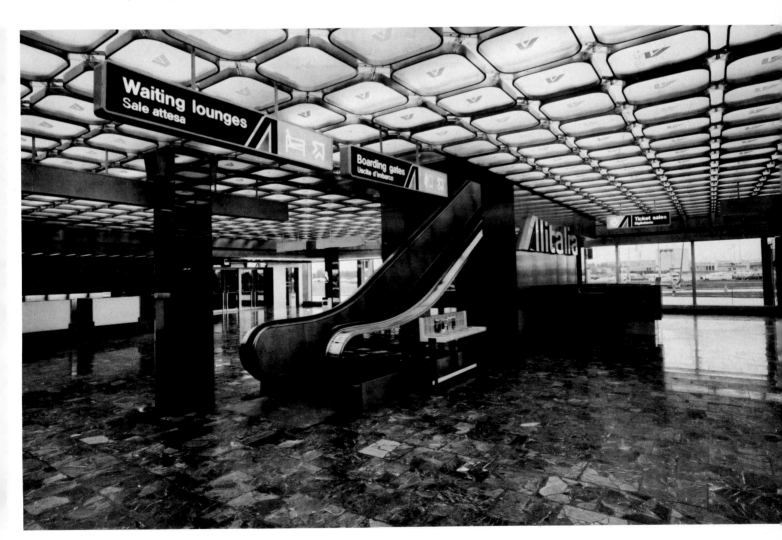

Photographer: WILLIAM GROENDYKE
for C.S.G. Design Associates, Inc.

I believe that professional photography is a very demanding, competitive, challenging, and rewarding profession; I feel that I am only as good as my last photograph and that I must be constantly learning and improving my skills, both technically and creatively.

This photograph was done as an experiment to augment my portfolio and to show some of my clients what can be done with simple items which are available in any grocery store. The lighting consisted of a single electronic flash as direct backlight with a white card as fill. The lens was a 300 mm Rodenstock Imagon, which is a special soft-focus lens that uses discs rather than a diaphragm. It works best with backlight. The diffuse quality of the lens softens the harshness of the direct flare. The aperture was approximately f/7.7 with a 1.20 neutral density filter. I also used a CC10 red filter to enhance the red of the tomatoes and to warm up the mushrooms. The baskets in the picture are part of my antique collection; they were used by the farmers of New Jersey about the turn of the century and were handmade from teakwood and metal.

Photographer: IRWIN HOROWITZ
Alvin Grossman for *McCalls*/The McCall Publishing Company

For a magazine story on new mini-appliances. How do you depict in a photo story the small size of the appliances to be shown? The opening spread showed a portable electric clothes dryer sitting in what appears to be a normal laundry basket. However, to symbolize the mini-size, we had a huge replica basket woven somewhere in the wilds of Brooklyn. The giant necktie was purchased from a Broadway novelty store. The props were assembled and composed to achieve a realistic look, and were ready for the camera. I used electronic bounce flash as the exposing light source, an 8 x 10-inch camera and EKTACHROME Professional Film, Daylight. A fun still life!

Photographer: JERRY WEST
for *The Playboy Wine and Spirits Cookbook/*
Playboy Publications

Although these sizzling steaks were photographed for a cookbook, another excellent use would be a large point-of-purchase poster, adding great visual appeal to a meat market wall, almost guaranteeing increased sales.

A bank of 1200-watt-second electronic flash units acted as a main light from the right-rear of the set. One 600-watt-second unit under the leaded glass tabletop provided secondary illumination. The lens was stopped to f/45 and one flash of the electronic units exposed the scene. The shutter was set for 1/5 second to record the brandy flame. The film was 8 x 10-inch EKTACHROME Film.

Preparing Photographs for Photomechanical Reproduction

Since the majority of photographic illustrations are destined for photomechanical reproduction, here are some ideas of how you, the photographer, can help the engraver and printer to make a successful reproduction from your original photographs. Incidentally, following these guidelines will endear you to your client as well, because you will save him a good deal of money in plate preparation costs.

Black-and-White

A good black-and-white reproduction print *should* look good. It should have detail in the shadows and modeling in the highlights. It should have the proper contrast—not too flat nor too harsh. It should have a nonferrotyped glossy or smooth surface. It should be from 1½ to 2 times larger than the size at which it will be reproduced. It should have *no* physical defects such as dust spots, cracks, scratches, or black spots.

Most reproduction prints need some amount of retouching done to them. A skilled retoucher will help control distracting or unnecessary highlights, subdue overbright backgrounds, and enhance small details. However, it should be the photographer's goal to give the retoucher as little work to do as possible. Beware of the overenthusiastic retoucher who turns *your* photograph into *his* drawing!

When more than one picture is to be used on a page, real economies can be effected by making all the prints to the same reproduction ratio and pasting them into position on a layout. When it is not practical to paste them into a layout, savings in plate costs are still possible by making all individual prints to the same reproduction scale. These scaled prints should be made from the original negatives, not copies. Making scaled prints may increase the photographic costs, but it reduces the reproduction costs more. Since the assembly of prints must be made eventually, it is less costly for the photographer to do it. And he will be able to compare the print quality at a point where reprints for tone or contrast are easily and inexpensively made.

Color Transparencies

All of the precautions that pertain to black-and-white prints apply to color transparencies with triple emphasis. They should be sharp where sharpness is needed. Highlights should have modeling. Shadows should not be lacking in detail. Contrast should be normal and density proper. The extra ingredient most important here is that the color balance should be absolutely correct, with neutral highlights and shadows.

A great deal of importance should be placed upon the color quality of the method of viewing transparencies for reproduction by all concerned, and everyone should use the same type of viewer. The American National Standards Institute has defined a standard light source and viewing conditions for transparencies. Here is a portion of the definition:

In 1972, standards on viewing conditions concerned with both reflection art (photographic prints) and transparencies in the 4 x 5- to 11 x 14-inch size area were approved by the American National Standards Institute (ANSI). Two areas were considered:

1. *Color quality appraisal:* Involves the comparison of original transparencies or reflection art with their photomechanical reproduction.

2. *Color uniformity appraisal:* Involves the comparison of preproduction proofs or press proofs with subsequent production pressruns, as well as continued evaluation of press sheets through an entire production run.

The first area is of more immediate interest to photographers.

The recommended standards for viewing conditions for *Color Quality Appraisal* refer to the three controlled conditions:

1. Original artwork and proofs are viewed under lighting of the same color temperature and color rendering quality.

2. The viewing conditions provide that original artwork and proofs are viewed under conditions that reduce differences in appearance be-

tween the two when they are viewed together for comparison.

3. The areas surrounding the viewing areas have been designed so as to be similar in different locations and to minimize visual differences in interpretation.

The conditions of most general interest for the viewing equipment are:

1. The color temperature of both the transparency illuminator and reflected copy/printed sheet is 5000 K.

2. The various wavelengths of light are in correct proportions to produce the 5000 K.

3. The transparency should have an illuminated border at least 2 inches wide on at least three sides of the transparency.

4. The position of the reflected copy or reproduction and the light source must be such as to minimize specular reflection.

5. The physical surface of the viewing booth and the surrounding viewing room must be neutral in color and make no color contribution to the viewing condition.

Two questions to ask when purchasing viewing equipment for this purpose are: "What is the color temperature?" and "Does the Color Rendering Index fall between 90 and 100?"

Color Rendering Index (CRI) is a number indicating the adequacy of the light source to blend all the ingredients making up the color spectrum in order to produce truly white light.

The ANSI committee assigned to define the needs of the industry has recently drafted a proposal covering the viewing of projected slides such as 35 mm or 2¼ x 2¼. The proposed specifications state that the color temperature of the projected image should be 5000 K and that the brightness should be equal to that of the standard 5000 K transparency viewer. It is expected that the CRI standards will be met. The image to be viewed should be projected on a screen to a size commensurate with the average color reproduction on a printed page. The screen should be hooded to protect the image from any incident or surrounding light.

Further specific information on these important standards for viewing transparencies can be obtained from the American National Standards Institute, 1430 Broadway, New York, N.Y. 10018.

As with black-and-white photographs for reproduction, some retouching is usually necessary on color transparencies. If a retoucher works on a transparency with dyes, he must be certain that the dyes he uses have the same photographic separation characteristics as the dyes contained in the transparency itself. *This is very important!* More plate correction fees are caused by bad color retouching than anything else. (Kodak Publication No. E-68, *Retouching Color Transparencies*, is available from Kodak. See inside back cover.)

When more than the usual amount of retouching must be done or when the contrast range of the transparency is greater than it is possible to reproduce photomechanically, dye transfer prints can be made. The retouching is then done with the exact same dyes used to make the print. Density and contrast corrections are easily introduced during the making of the print. Although dye transfer prints are relatively expensive compared to other color print methods, the superior results and the ease and reproduction fidelity of retouching makes them well worthwhile.

When a number of color photographs are to appear in a single spread, much money can be saved by doing all the original photography to the same scale, so that the transparencies can be ganged and separated or scanned together.

Duplicate Transparencies

When shooting all transparencies to the same scale is impractical or when the original photography is done with a 35 mm camera, excellent presentation transparencies and reproduction copy can be had via duplication. KODAK EKTACHROME Duplicating Film 6121 (Process E-6), in the hands of an experienced technician, can produce properly scaled, cropped, and color-corrected duplicate transparencies of a quality so high that they are difficult to distinguish from the originals. Therefore, the client receives from the photographer a complete package ready for the printer with no concerns for further preparation or reproduction.

Whether your photographic product be black-and-white prints, color prints, or transparencies, present them to your client as finished works of art—with pride. Mount the prints carefully on warp-resistant double-weight mounting board covered with an acetate overlay, a mat cut to the proper cropping, and a cover sheet. By all means, sign your work. Stamp your studio name on the back of the mount and put your trade logo on the cover sheet. If your photograph is in the form of a transparency, mount it in an acetate sleeve with a translucent panel on the emulsion side between two single-weight mounting boards containing a window of the proper size and position to crop the picture. However, do not embalm the transparency so securely in plastic that the platemaker has difficulty in removing it for his separation work. Many films have been torn in the effort to remove them from their mounts. Again, sign your work; put your studio logo in the corner. Make a production of presenting your work to your client. After all, it's part of you, your creation, and your bread and butter. If you don't show that you believe in and have pride in your own work, your client certainly isn't going to—and your income will suffer.

Working To A Layout

Some of the photographs pertaining to this chapter, taken at face value, have a strange, unbalanced, unfinished look. They require an overlay sketch to complete the picture. This is because they are only one element in an advertisement, conceived and executed by several people.

Usually the product manufacturer turns to an advertising agency for his product promotion needs. The agency assigns an art director to produce a series of sketches and layouts containing various ideas for selling the client's product. One is chosen, and then, after the idea is well fixed in the minds of all concerned, the photographer is brought into the act. It is his task to produce from the artist's sketch a realistic photograph which will sell the product, thus fulfilling the need of the manufacturer and the promise of the advertising agency and its art director.

Art directors convey different degrees of authority to their layouts. Some are only thumbnail sketches, showing approximately what they had in mind. Others contain carefully placed elements but leave the general feeling to the photographer. Still others are finished, highly detailed renderings, with every last item presented. Usually these are the layouts that are reduced to the film size, traced, and taped to the camera ground glass.

Working to a tight layout can be a problem if the artist did not follow the natural rules of perspective. There have been instances when special furniture in graduated sizes had to be made to fit a layout, or where a chessboard and chessmen were carved in special perspective for a tabletop still life. Usually, however, a good layout demands only the proper use of the swings and tilts of the view camera to produce the required photograph.

Since the commercial photographer is usually hired by the advertising agency, it is in his self-interest to do all in his power to make the art director look good in the eyes of the client. By doing his job in following the layout meticulously, and by presenting creative ideas to the art director only, the photographer will be able to grow with that agency, through client after client, with an excellent relationship. The client, the ad agency, and the photographer can be likened to an equilateral triangle; each side depends upon the other two. If one buckles, they all go down.

The following speech was written by the late William A. Reedy, Senior Editor and creator of Kodak's premier publication *Applied Photography* and author of the book *Impact–Photography for Advertising*. Although never given in public, it contains sentiments appropriate for this book.

THE CARE OF CLIENTS by W. A. Reedy

It requires not a little courage and some equivocation to comment on what a client expects from the photographer. Quite frankly, many clients do not know what they expect because they are not at all sure what they want. They know that they want a successful picture, and perhaps we can define the successful picture as being the one you make which he recognizes as the picture he would have told you he wanted if he had thought of it himself. Of course, this is not entirely a bad situation, since by not knowing what he wants, the client feels he must come to a professional with his problem.

However, when the client's problem is combined with a client who does not recognize a solution when he sees it, a photographer has two problems: The client's original problem and the client himself! Probably, most clients want to be pleasantly surprised. And certainly they expect a professional result. They expect technical quality of a very high order; they expect some artistic and creative contributions; and they expect that the photograph will reproduce decently.

Knowledge of photomechanical reproduction should be part of the professional training of a photographer because, in the first place, one cannot always trust the client to have this knowledge. And, in the second place, this is the usual end use of a commercial photograph, and a photographer should not be in the position of having the client tell him that the picture will not reproduce well.

An aura of authority on the part of the photographer is probably one of the major necessities to pave the way to success. This air of authority plus a display of genuine enthusiasm for the project involved does much to prepare the client to be pleased with the result.

This aura of authority comes about only when the photographer has confidence in his ability and uses this confidence to take charge of the production. You have all heard about the giraffe being the result of a committee decision and, unfortunately, when the photographer does not take charge, the picture is all too often the result of group thinking. The successful photographer must have in himself a sense of responsibility not only to his client, but to the picture and to himself as a creator. Every picture should be the most important thing in life at the moment of its making. And while it may be only a little stinker, it's important to the client.

And if the photographer becomes really involved in the problem of creating this picture, he will find a creative thrill in reproducing the simplest things. All objects have some characteristic which is distinctive. And to make soft objects appear soft, smooth ones smooth, and rough ones rough, is part of the uniqueness of the photographic process. The theme of a photograph need not be a contribution to world peace to be deeply satisfying to the maker.

Then there is the maker of personal involvement. The photographer should take the trouble to find out what the product or idea is all about and what the client hopes to accomplish. I'm sure we have all seen or heard about photographers who greet the client with "Well, what do you want?" The making of a photograph is not such a simple problem that homework becomes unnecessary.

The attitude of the photographer towards the job is of major importance. There is a professionalism about paying attention to detail and delving into the subject matter about to be photographed which engenders confidence on the part of the client.

The client also has reason to expect that the photographer be reliable both in keeping promises and in applying professional standards to his work. When a photograph is clearly not up to the professional level expected by the client, the photographer should not wait for the client to tell him about it. He should be able to judge for himself and admit that he made a mistake.

On the other hand, when he knows he did not make a mistake and the photograph is a good one, he should be enthusiastic. There is no salesman as effective in convincing the client that he got what he wanted quite like the enthusiasm of the photographer for a job he has just completed.

There are occasions when the client seems to feel he knows exactly what angle, what light, what everything he wants in his photograph which you, as a photographer, instinctively feel is wrong. The solution to this problem is to do the picture the way the client wants it to be done, and then do it your own way which, hopefully, will be a far superior way. There is probably no better way to build a photographic clientele than to be proven right in a final showdown between his way and yours.

This does not sound like very good business in that the photographer is producing two pictures for the price of one. But the photographic business is a creative business and cannot follow strictly the rules of retailing other commodities. Creativity is the art of making something out of very little, and there is a very narrow line between an outstanding illustration and one that is merely adequate.

All of this comment is based on the assumption that the photographer is in the photographic business because he likes photography. Many photographers feel that they are artists in their medium. If they would be artists, then they must live up to the discipline which controls the artist's life. I am sure that you need not be told that this discipline is a severe taskmaster. There is required a sort of intellectual honesty which is akin to that sense of responsibility mentioned before. This sense of honesty is very closely linked to the standards of excellence to which one works. These standards are the guidelines which determine one's eventual fate as a photographer. When the photographer is easily satisfied, he ceases to grow. And what is worse, he cannot distinguish between good and bad. The fact that he made the picture becomes enough of a recommendation of excellence, and this is a tragic basis for judgment.

There is a lot more work in creating a photograph than is normally realized by anyone who merely looks at the resultant picture. For example, there is a matter of housecleaning if the picture is made on location so that there are no distracting details or badly lighted, out-of-focus objects such as a stick in the foreground, which can downgrade an otherwise beautiful illustration.

While photography is not the easy thing of merely pointing a camera and snapping the shutter, it should always be a matter of some joy to the photographer, no matter what the subject matter might be. If there is no joy in photography, and one finds himself bored with the kind of pictures he is asked to make, it might be wiser to consider some other line of endeavor. There is no more boring picture than that created by a bored photographer.

The enthusiastic photographer with a sense of responsibility will have an attitude very similar indeed to that displayed by craftsmen and artists in other media. I recall a statement of a broommaker quoted in National Geographic's new books on craftsmen in America. He said, "If you put out sorry stuff, you'll ruin your trade." What he didn't say but intimated was that if you put out sorry stuff, you'll ruin yourself as a craftsman. This evidence becomes plainly visible to present and potential clients.

Most artists and craftsmen in other media devote a portion of their time and materials to making things which are not necessarily ordered by clients but are simply made to try out an idea or to please themselves. It is through this sort of experimentation and personal expression that the artist grows. I would like to think that photographers save a little time and a little piece of film for experimental purposes. One might call this seed money. Such experimental photography not only serves as a demonstration of what a photographer can create; it also provides sources of ideas to be applied to future assignments. It is unfortunately true that the photographer who no longer has time or desire to experiment has ceased to grow creatively unless he is very fortunate in having only clients who wish him to experiment on their time. And if such a utopia exists, I'm sure I do not know where it is.

Photographers who make their living making pictures are proud to call themselves professionals. But they should realize that the word "professional" implies more than the receiving of money for pictures. I certainly do not recommend a stay in the hospital, particularly a lengthy one. I was recently unfortunate enough to have four weeks of this doubtful privilege.

During this stay I observed almost hourly demonstrations of what a professional attitude is all about. There is an attention to detail, to perfection, and to accuracy which could well be emulated by photographers. Of course, you say that people in hospitals are dealing with human lives and, therefore, their procedures and attitudes are extremely important and necessary. I can only reply that if photography is important enough to devote one's lifetime to its practice, it should also be important enough to attain such a professional attitude.

Photographer: WILLIAM A. REEDY
for *Applied Photography*

Photographer: AL GOMMI
Owen W. Coleman
Coleman, LiPuma and Maslow, Inc.
for *Applied Photography*

Rarely is it possible to document the evolution of a commercial photograph. However, here is a picture history of such a photograph—sans the many necessary conferences, phone calls, and letters. For a Kodak publication, editor Bill Reedy developed the magazine concept showing how package designers utilize photography. To accomplish this task, Bill called on an acknowledged leader in the Madison Avenue food illustration field, Albert Gommi. In turn, Al recruited Owen W. Coleman, President of Coleman, LiPuma & Maslow, Inc., industrial designers, to conceive the first package design. "The design layout (see below) for imported wine" says Mr. Coleman, "projects a visual image of what wine is all about—saying that wine belongs with food, and food with wine." Mr. Coleman also executed a handsome new container to house the wine product. At the point that layouts and meetings were completed, Al took command. He and Owen gathered the props: aged cheese, freshly baked bread, ripe grapes, graceful goblet, and gilded figurines. Then Al composed the photograph as only a master food photographer can. Our cover shows the instant of completion of the assignment.

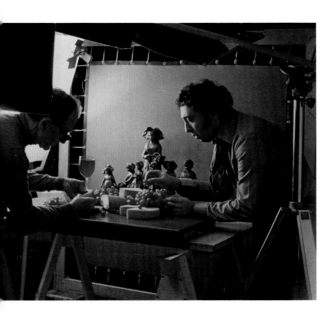

And here is the final photograph, certainly a beautiful picture. The photograph projects old-world charm, which enhances the marketing image, and its mood is one of fine living and good taste. The beauty of the package design and photography encourages both multiple display and sales when stacking four cartons together. Don't look for "Les Petits Vigneorns" at your vintners. The entire exercise appears only in print.

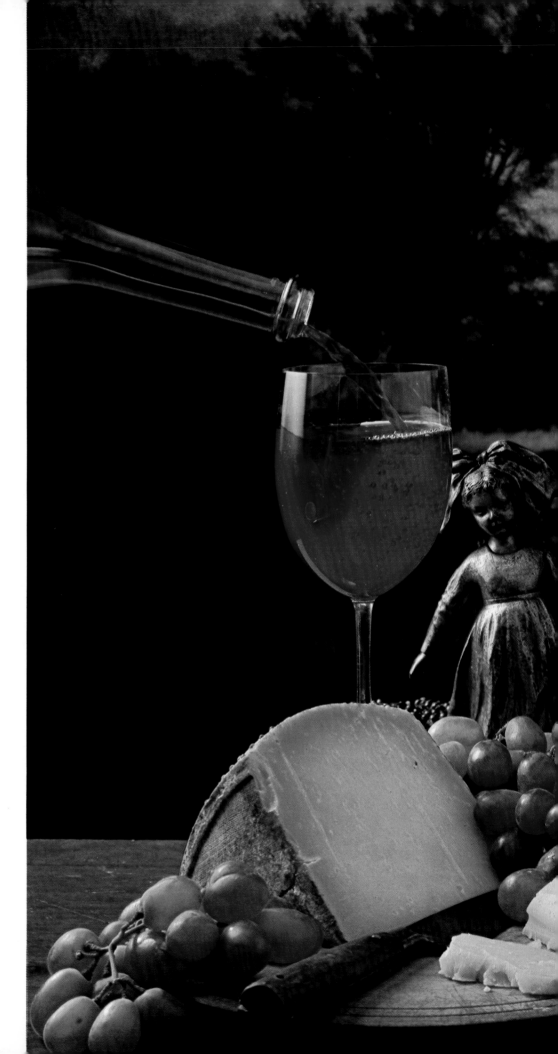

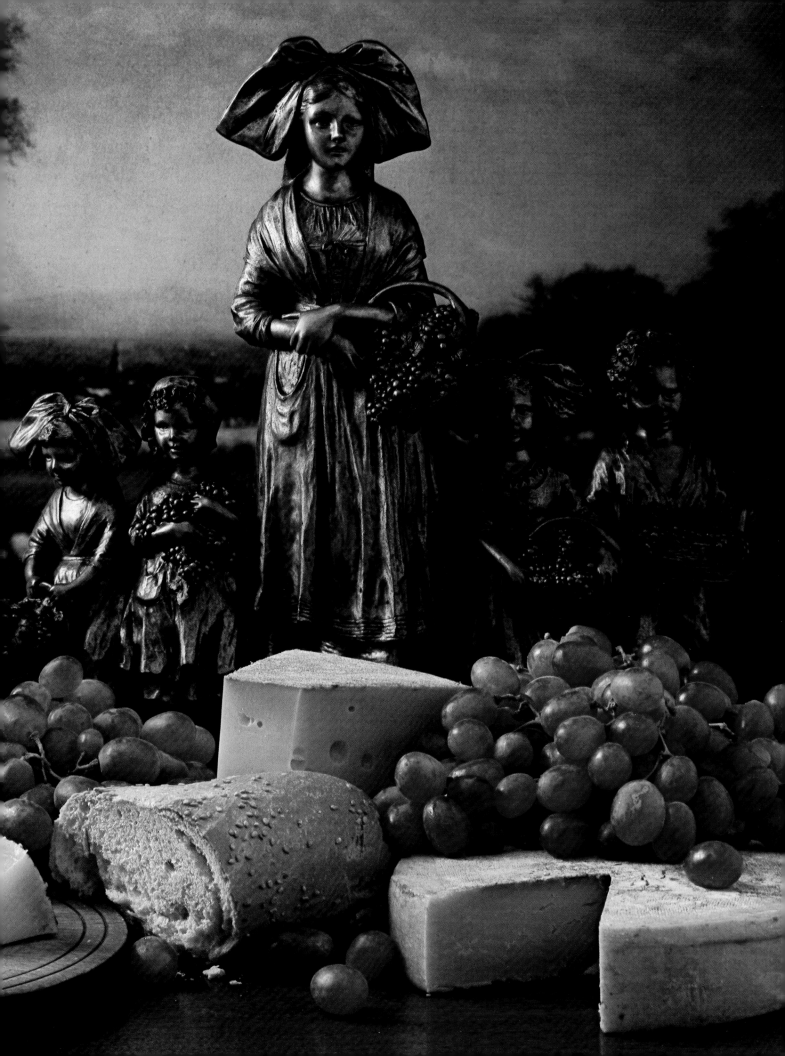

Photographer: CHARLES WECKLER
Weckler's World
for Boise Cascade

*The radio telescope, high on a hill, was photographed late in
the day as the sun was setting. Two pieces of window screen in
front of a 250 mm lens caused the star effect. A Hasselblad
camera exposed color negative film. The repro print, on
KODAK EKTACOLOR Paper, shifted from warm to cold blue.*

Vision.

Seeing beyond the immediate
is an important in business
as in understanding the universe.

IN its extreme compulsion,
points in new directions with new ideas.

all type and logo should reverse!

Vision.

Seeing beyond the immediate
is as important in business
as in understanding the universe.

Front panel scheme
Check for other
photo crops!

CRESTMONT
Ice Cream

Vanilla · Strawberry · chocolate

Front panel scheme.
Check for other
photo Crops!

CRESTMONT

Ice Cream

Vanilla · Strawberry · Chocolate

Photographer: PHIL PRESTON
John McSherry Studios
Stuart, Gunn & Furuta, Inc.
for The Great Atlantic and Pacific Company

On occasion, the same layout is used repeatedly and changes are made in subject matter only. When the ideal format for an ice cream carton is obtained, it is only necessary to substitute the ice cream flavors—and dishes, and cloths, and all the props, to come up with covers for an entire line of products.

The client desired a slight melting to show on the ice cream for taste appeal. He also wanted the props and background lighting subdued. The lighting was tungsten; the main light was a 750-watt spot from left rear and two 250-watt diffused floods filling from either side of the camera. To keep the props behind the subject as small and far away as possible, we used a 10-inch wide field lens. Actually the props were only 24 inches from the ice cream. All three photos were exposed on 8 x 10-inch EKTACHROME Professional Film, for 2½ or 3 seconds at f/45.

Photographing a heat-sensitive subject such as ice cream with tungsten lighting is rather difficult. However, as you can see, the results are worth the numerous exposures necessary to obtain the exact degree of glisten to the product. A blast of electronic flash would define the texture and softness of the fine ice cream in this manner.

Photographer: CHARLES WECKLER
Weckler's World
for Wells Fargo Bank

The authentic stagecoach is the property of the bank, and on this occasion the horses were supplied by a rancher in the San Jose area. The ranch extended over more than 600 acres of hills and valleys. We worked from sunup to sundown, doing many pictures. This one was shot in the late afternoon, nearly at sunset. The coach was driven rapidly along a ridge and we were in the valley. Photographed on color negative film with a Hasselblad camera and an 80 mm lens. The print for reproduction was on KODAK EKTACOLOR Paper. The reproduction was a very satisfying 24-sheet billboard.

We deliver lots of interest for your savings.

SINCE 1852 WELLS FARGO BANK

Photographer: FITZ H. LEE
for Kraft Foods

A really great poster needs nothing but a word to say it all. It is
the ultimate in advertising, for it must stop the eye instantly, set
the mood in a flash, and start the sale with the desire it creates.
Here the freshness and abundance of beautifully ripe fruits and
vegetables portrayed by the photograph created an instant
desire; the 24-sheet billboard must have been very effective. The
subject was simply lighted with a single 1000-watt quartz
floodlight behind a diffusion scrim that extended completely
behind the table of vegetables. Two white cards to the right of
the camera reflected fill light into the product labels. On 8 x 10-
inch EKTACHROME Professional Film.

Crop tight for 24-Sheet POSTER!

Rubbermaid ®

rinse%able
sponges & scrubbers

All new packaging...

...and new displays for shelf and floor
to produce greater sales potential ▶

Rubbermaid®

rinse&able

sponges & scrubbers

All new packaging...

...this new display for your 2nd floor.
(& modular gravity-system optional)

Photographer: ED NANO
Studio Associates, Inc.
for Rubbermaid Inc.

Many times a good photograph lends itself beautifully to a number of layouts.
Here is a shot of a product in action. Notice that the photographic angle
emphasizes the distinctive "wasp waist" shape of the sponge. The versatility of
the photograph is proved by the many ways it was used. It appeared as an ad in
Chain Store Age, Discount Store News, Supermarket News, Hardware Retailing
and Progressive Grocer, as well as illustrating a series of catalog pages.

 The water tap was placed well in front of a diffusion screen covered with a
yellow gel. A 1200 watt-second speedlight behind the screen, triggered by a
photocell, provided the background illumination. The main light, another 1200
watt-second unit, was placed high and to the right of the camera. A foil reflector
filled in the shadows from the left of the 8 x 10-inch camera with a 19-inch Artar
lens. On EKTACHROME Professional Film, Daylight.

117

Ideas **Ideas** *Ideas*

This final chapter contains the essence of what professional photographic illustration is all about. With a little study and practice, the technical end of making photographs becomes natural and even easy. It is solving problems and translating ideas into successful photographs that makes photo illustration a challenging, enjoyable, and lucrative way of making a living.

The photographs presented here are examples of ideas brought to a successful conclusion through photographic technique. Some are laughably simple; some extremely complex. They all have one thing in common—the photographer worked hard to produce them and is very proud of his results.

The pictures are included in this chapter so you may study and remember them, and to stimulate you to greater creativity. They are accomplished facts; done; past. Take them as stepping-stones to developing your own original techniques and personal style.

If you can, even on the most mundane of photographic assignments, inject a little original thought, a new twist, or an unusual concept, then this book will have been successful and all of the efforts of the many talented people who have lent their photographs and their words to it will have been worthwhile. We will have passed along to you the knowledge we gained from that first generation of photographic illustrators, now gone. It is to be hoped that a measure of enthusiasm, dedication, and artistry has managed to find its way through these pictures and words as well.

Photographer: ANSON HOSLEY, FRPS
for Case-Hoyt Corporation

The first illustration in this chapter on ideas is so very simple that you could almost dismiss it with a nod to the fine sense of humor that it exemplifies. However, the accomplishment of the illustration embodies not only knowledge of the finer points of photography, but of entomology as well. The spidergram production data follow:

The idea was to produce a photogram of a live spider to be used in a cover design for a web offset papers brochure.

A live spider was necessary, for otherwise spiders tend to curl up into a tight ball, rendering themselves useless as models. For the illustration it was desired to have the spider's eight legs outstretched and positioned as in nature much as they appear when hanging from a strand of web.

In order to accomplish the desired photogram, a large tray of water was set up in a darkroom under safelight conditions. This was to act as a moat for a smaller floating inner tray intended to keep the spider from wandering too far.

A sheet of high contrast KODALITH Ortho Film was placed, emulsion side up, in the smaller float tray. A series of test exposures were made, using a small electronic-flash light source and a "stand-in" consisting of a common rubber band–the rubber band having approximately the same opacity as the spider.

After the correct exposure condition had been determined, the live spider was removed from the glass jar that had contained it and placed on a sheet of unexposed KODALITH Ortho Film within the floating tray.

The moat tray served its purpose and kept the spider confined while a series of photograms were made.

Although the electronic flash stopped motion, all of the poses proved undesirable due to the spider's lively activity. Not one of the exposures recorded the spider's eight legs in the desired positions. A simple solution to this problem was to return the spider to the glass jar and to place both in a film freezer cabinet at 0 degrees Fahrenheit for 10 minutes, thus causing the spider to become dormant. At this time the spider was taken back into the darkroom and placed on a sheet of the film, where the legs were correctly positioned with the aid of a pair of tweezers. Since this "frozen" pose had been achieved, there was no real need to use the electronic flash to freeze motion, but it was used anyway.

Seconds after the successful photogram exposure was realized, the spider warmed up to room temperature and took off on the fly–so to speak.

To create the thin strand of web, a piece of piano wire was stretched taut across another piece of KODALITH Ortho Film and a photogram made of it to be superimposed with the spider photogram. Aligned to the spider's orifice (spinneret), it represents the thin supporting web in the final print.

It is almost impossible to enter a room occupied by spiders without observing one, for spiders are great attention-getters. That was one reason for using a spider in this design. The other reason, if you consider the title of the brochure, is as obvious.

All of this may be considered an exercise in design and the employment of photographic techniques toward creating something meaningful out of simple props.

Photographer: WILLIAM K. SLADCIK
for Air King

The object of this photograph was to project an additional warmth within a living-area atmosphere. The star of the photo, as in most commercial illustrations, was the product. We also used a young live model, which complicated the procedure. We first shot with electronic flash to stop the action of the little girl playing with her doll. One flashtube in the table lamp and one bounced off a large white card above the set provided the light. Then we turned off all the lights in the studio and reexposed the heat element bar on the space heater for approximately 5 minutes. We actually wound up with two widely different exposures on one piece of film.

In the last 10 years that I have operated my own studio, I have searched and am still searching for new and different ways to use photographic lighting to create mood, or to convey a feeling or impression. I have found that this control of lighting can be accomplished only through much time and experience, because you have to learn to feel within yourself what the lights can or cannot do.

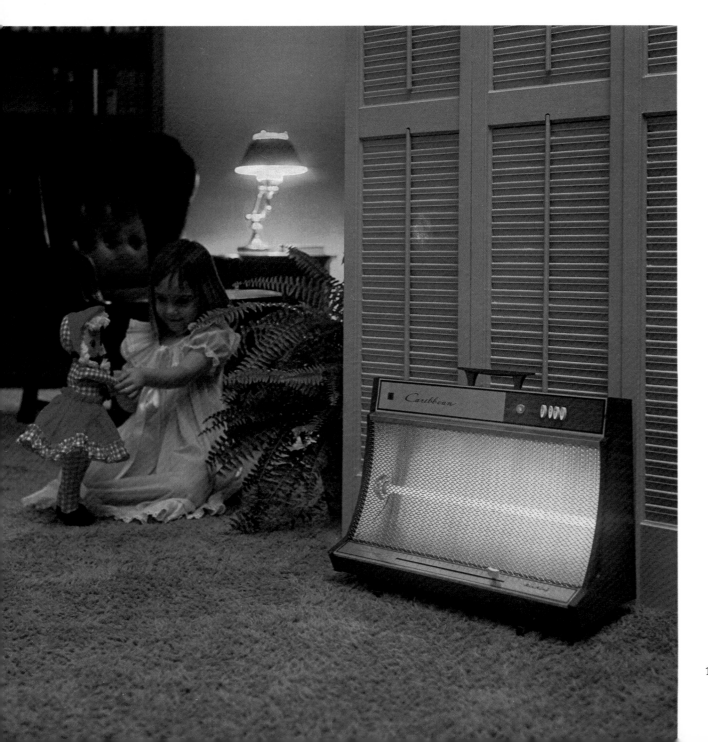

Photographer: ROGER BESTER
B. Lintas Brazil
for Atkinson's Perfume

*There is no lighting secret here,
other than setting up the shot in
the very early morning light on a
rainy day and dodging in and out
to avoid the heavier downpours.*

*I used a Hasselblad 6 x 6 cm
camera with a 50 mm lens, plus a
No. 2 Softar (soft focus lens
attachment) and a sheet of glass
with petroleum jelly and raindrops
on it. However, more was done in
the darkroom in making a
duplicate transparency; that is, by
controlling the soft focus areas on
the man's trousers and the sky in
the background. The shot was
made for an Atkinson's Perfume ad
and is running constantly in the
principal women's magazines here
in Brazil.*

120

Photographer: ED NANO
Studio Associates Inc.
for Rubbermaid

In exact opposition to the high-key illustration of translucent tablecloths, here is a long-density-range photo. The distinctive shape of the sponges is delineated by a background of wet black vinyl. The illumination is from a single soft floodlight placed high and behind the set—similar to the high-key illumination.

Photographer: BEN CALVO
for *Woman's Day*
C.B.S. Publications

The subject was translucent summer tablecloths and the problem was to show that translucent quality, keeping the picture light and airy, but at the same time maintaining a rigid tabletop.

So, tables were constructed of Plexiglas acrylic plastic with tops heavy enough to support the props and to show an edge for a little realism. A rear-projection screen was set up behind the tables and a reflective Mylar polyester film sheet stretched on the floor below the screen, under the tables. The projector with the sky image was positioned so as to cause a hot spot behind the tablecloths. A single quartz flood bounced off the ceiling lighted the tabletops and props. Two exposures—one of 15 seconds for the tabletops and props, and one of 2 minutes for the projection of the sky—were given with an 8 x 10 camera, 12-inch lens at f/32, on EKTACHROME Professional Film. A black drape was drawn across the projection screen during the foreground exposure.

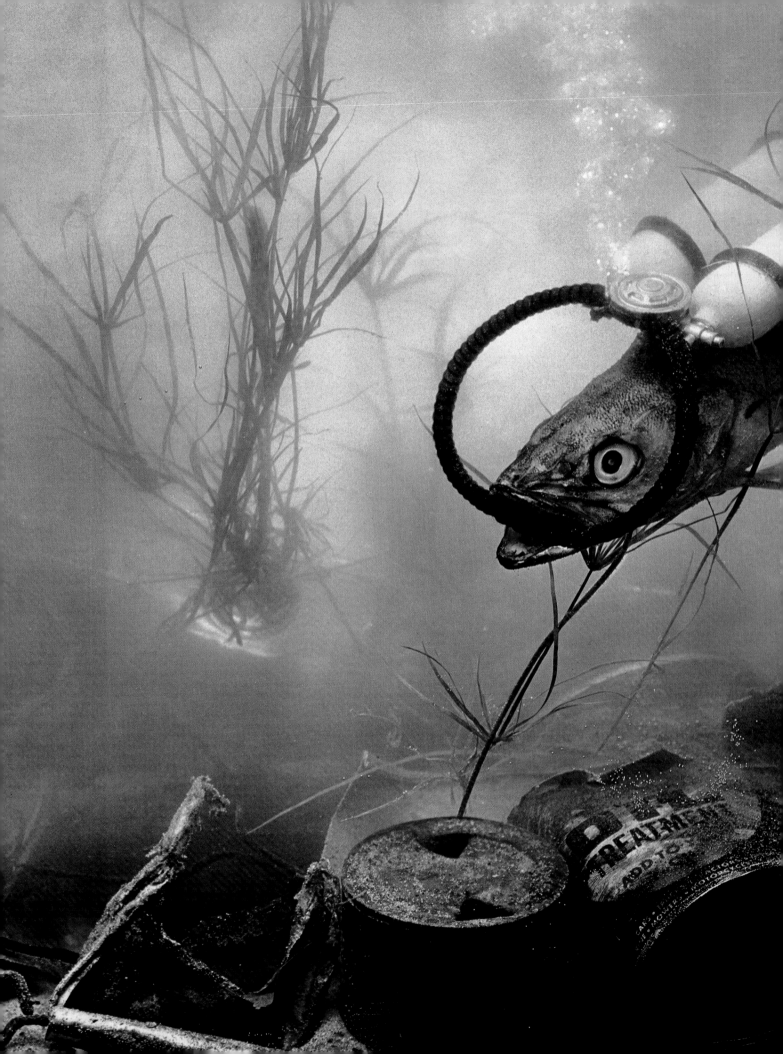

Photographer: TONY GARCIA

**A very effective poster.
Social comment with a bizarre
sense of humor that evokes
a double take every time.**

*Once, I was watching the Jacques Cousteau
program on television and the idea of men being
able to breathe underwater with the aid of
Aqua-lung scuba gear fascinated me. My
thoughts wandered to questions such as: Fish
don't need Aqua-lungs to breathe—or do they, in
polluted waters? Breathing, as well as living,
must be difficult if not impossible for them in
such an environment today! So, in my mind, I
put together the picture of the fish wearing the
Aqua-lung.*

*Now I had to figure out how to make the
picture in my mind a reality. Obviously, I had to
do it in the studio (I can't swim), so I got a large
fish tank, put sand in the bottom and added
objects such as tin cans and bottles and other
junk that would certainly be found on the bottom
of any ocean or river today. I also included
seaweed and rocks.*

*I bought the fish from a local fish market,
attached the Aqua-lung and anchored the fish to
the bottom of the tank with a piece of wire that
ran through the entire length of its body. The
wire not only held the fish in place, but also
allowed me to curve it in a natural position.*

*To create the bubbles that came from the
Aqua-lung I used a fish tank air compressor and
ran a tube from it through the fish to the
Aqua-lung.*

*During the preparation of the set, bubbles
formed on the inside of the glass tank. I removed
them by wiping the glass with cotton soaked in
KODAK PHOTO-FLO Solution.*

*To create a feeling of ocean depth, I placed a
silver reflector behind the tank at an angle. My
light source was a 2400 watt-second electronic
flashtube placed directly over the tank. I used an
8 x 10 Deardorff camera with a 12-inch lens.
Exposure was 1/60 second at f/11. This allowed
the background to go slightly out of focus. The
film was KODAK EKTACHROME Professional
Film, Daylight.*

*My feelings about commercial photography
are more complex than I have space for here, but
basically I think it is a real challenge to keep
coming up with new ideas and to execute them in
a manner that meets my own standards. Each
photo must be graphic, must express a concept or
a distinct point of view, and each photo must be
beautiful. It isn't good enough to make a
photograph just for my own visual pleasure; the
photograph must express a specific idea to the
thousands of people who will eventually see it in
print. Each photo must be fresh and exciting,
and must have impact.*

Photographer: CHUCK ASHLEY
for Sava-Watt Industries

In thinking about how to attack the problem of making a specific commercial illustration, I try to use the subject, or the need for the picture, as a starting point. For instance, in this photograph of a new energy-conserving fluorescent lighting unit, which screws into a conventional overhead incandescent bulb socket, I reached the conclusion that light was what was for sale, then used only light to sell it.

By soldering wires to the back of the socket and running them along the two rods used to support the unit (hidden by the unit itself) from a black background, I was able to make the deluxe warm white fluorescent tubes glow. That particular type of tube was used because it is closest to the 3200 K balance of EKTACHROME Film. Two small spotlights on either side of the unit were balanced to the exposure of the ring light itself. Two other ring lights were placed at the left rear and right foreground of the set and a second exposure through a diffraction grating produced the multicolored ring images.

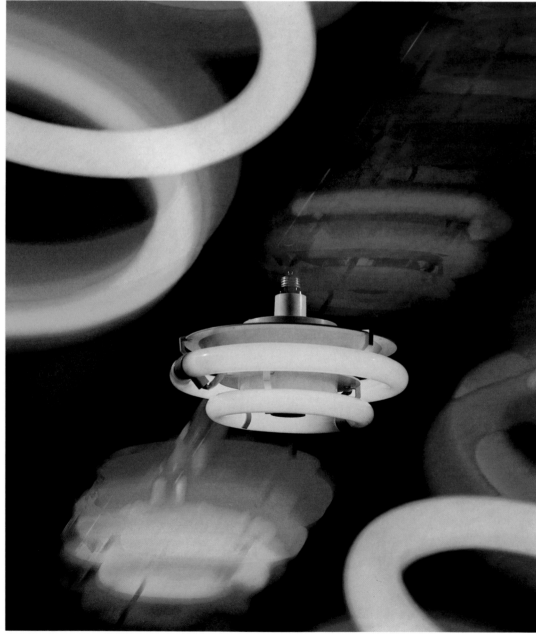

124

Photographer: JIM JOHNSON
Feldkamp-Malloy, Inc., Norm Tweety
for The Wurlitzer Company

Commercial photography is a series of compromises—the end result being an illustrative piece of art. The wants and needs of the client, plus the ideas of art directors, mixed with the idiosyncrasies of the subject to be photographed, all add up to the physical and mental gymnastics of our everyday lives as photographers.

Commercial photography is becoming more sophisticated in its ability to motivate the public. This, plus our refinement of it, leads to a more pleasing piece of art.

Here, Wurlitzer needed a shot of their product featuring their new tape cassette that projected a fresh new look for a brochure illustration. The 8 x 10-inch camera with a 70 mm Super Angulon lens (a lens designed for 4 x 5-inch format) was positioned about 6 inches from the corner of the organ. A piece of plate glass, smeared with petroleum jelly, was close in front of the lens. Two 750-watt spotlights from the left rear illuminated the keyboard and the face of the instrument. A 150-watt small spot picked up the side. A large sheet of bright aluminum foil behind the organ reflected distorted images of strips of colored paper from the left of the set. The corners of the photograph were darkened by the lack of coverage of the lens.

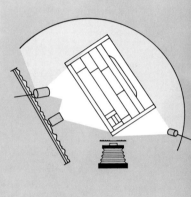

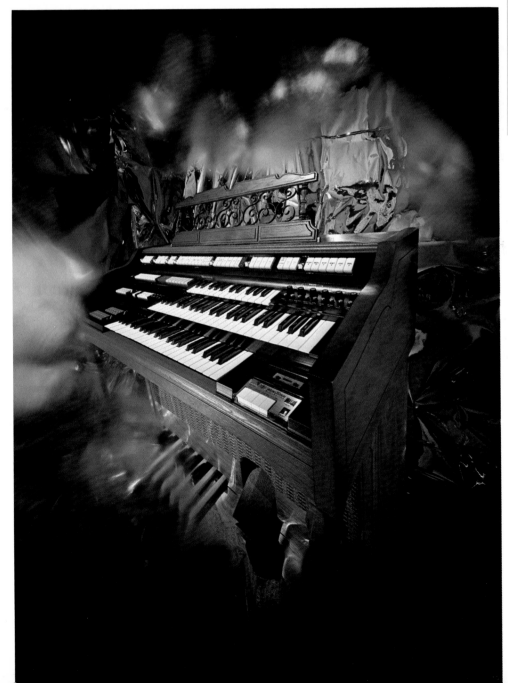

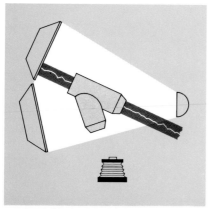

Photographer: JIM JOHNSON
Feldkamp-Malloy, Inc.,
Jack Brouwer/The Jaqua Company
for Taylor Forge

The casting had to appear as if in space or limbo with electricity passing
through it. This effect was accomplished by means of a double exposure.
First, the casting was illuminated against the dark blue background with a
750-watt spotlight, covered with a purple gel, from the right. Fill light was
from white reflectors above and to the left. Exposure for this was 7½ seconds
at f/32½. The lightning was created by inserting a black-painted acetate
cylinder with etched lines, containing three 40-watt showcase bulbs, through
the casting. The other lights were extinguished and an out-of-focus exposure
of 15 seconds at f/11½ was made.

Photographer: GRIGNON STUDIOS
for The Harter Company

**In direct contradiction to most furniture photographs,
which depict the product in a set ready to use,
here chairs are starkly alone, in black space.**

*The photo was used as a cover on a brochure. The
manufacturer's name, Harter, was reversed out of the area at
the top. The emphasis was on the lines of the chair to create
impact for the cover. We set our focus on the front chair,
allowing the depth of field to fall off on the others. The
lighting, which was direct, emphasized the texture on the back
of the big chair, and the edge lighting on the others established
form. The cropped chair on the right established the base and
the chrome.*

**Photographers: SAM KANTERMAN
and BILL VIOLA**
for Schenley Industries

**The sparkle of wine is vividly portrayed in
this illustration. It was done with a single
exposure. Two soft floodlights illuminated
the bottle, and, as the exposure began, five
colored Fourth-of-July sparklers were lit.
Since the exposure took several seconds,
the tracks of many burning particles
were recorded.**

Photographer:
IRWIN HOROWITZ
Marschalk Advertising
for Schrafft's

*This is the story of a Schrafft's
campaign for some of their many
ice cream flavors. The first photo,
"coffee," was of a construction of
the carton and pieces of an antique
tin coffeepot. A model-maker put
the prop together. The subject was
lighted softly with bounced
electronic flash. At the precise
moment that the smoke was piped
through the carton and up the
spout, the shot was taken. The
container had been frozen to
achieve an appetizing and
animated, if contradictory, effect.*

*A simple-looking solution
which demanded the eye of an
artist, the care of a scientist, and
the patience of a saint.*

*The second flavor, chocolate,
again involved a model-maker. A
mold was made from the ice cream
carton and the casting was done
with liquid chocolate cooked in a
vat on the studio range. (Imagine a
photo studio with an overpowering
chocolate aroma!) When the carton
in chocolate was unmolded, it was
positioned next to giant bars of
chocolate. Some sculpturing was
done with modeling tools for the
final effect and the statement was
ready for the camera. Soft,
simulated daylight lighting was
used to pick up every nuance of
tone in the chocolate.*

*The vanilla and strawberry
shot was relatively simple. A
number of well-filled frozen ice
cream cartons were sliced with a
very sharp knife and the most
photogenic one speared with a
sparkler, placed on the darkened
set, and, as the sparkler burned,
exposures were made. A single
spotlight illuminated the carton
with a white card for fill light.*

128

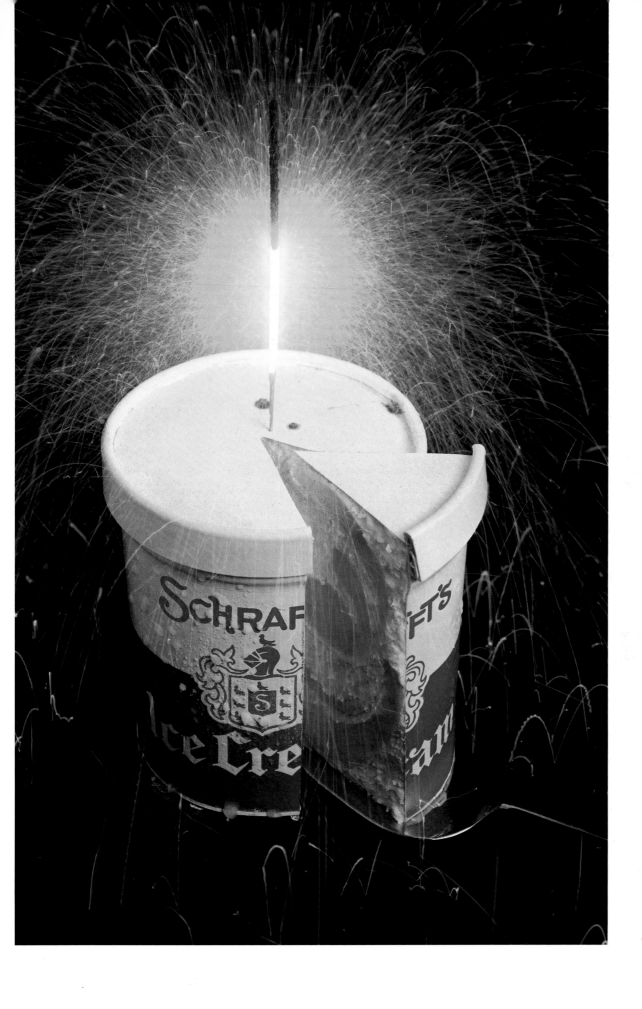

Photographer: FRED LYON

For an editorial page, non-specifically illustrating champagne, I was asked to submit a choice of eye-stopping approaches. Here, I used the principle of the Harris Shutter—three separate electronic flash exposures with a Balcar strobe unit, each through a different filter (No. 25, 38A, and 61) and a plastic condenser lens. The glass and bottle needed to remain stationary, so the bottom of the bottle was cut off and the bottle held in a laboratory clamp. This allowed us to make three separate pours and expose each through a separate filter. Exposures were bracketed. The lighting was complex, since the bubbly effect is most pronounced backlighted on a black background. One electronic flash was carefully placed to prevent flare, and the entire set goboed off with black cards. This technique is useful for many applications. Shot on KODACHROME Film with a 105 mm Nikor lens.

What can I say about commercial photography? It's important to think about each job before plunging in, because inspiration may not strike on cue. It's vital that the client divulge the primary purpose and use for the picture, as well as possible auxiliary uses. Analyze the character and content of the subject matter with an eye to pictorial possibilities and treatments; the use of pencil and paper is highly recommended at this point. Finally, make innovation a habit. This lifts you out of the often low-paying role of cameraman into the realm of creative communicator. My own approach is visual seduction —motivating people to act in reaction to the pictures.

Happily, the tools, materials, and technical information now available make innovation in photography much more accessible to today's energetic photographer.

Photographer: FRED BURRELL

Bob Ramsay, for Smith-Kline Corporation

**Illustrating the chapter title "Ideas, Ideas, Ideas"
with just that: A series of gem-like distillations
of a very fertile photographic mind.**

*EKTACOLOR Paper prints of a girl's face were used to obtain
the eye, nose, and mouth that accompanied the allergy-
affecting rose, strawberry, and feather. The patterned blocks
were purchased.*

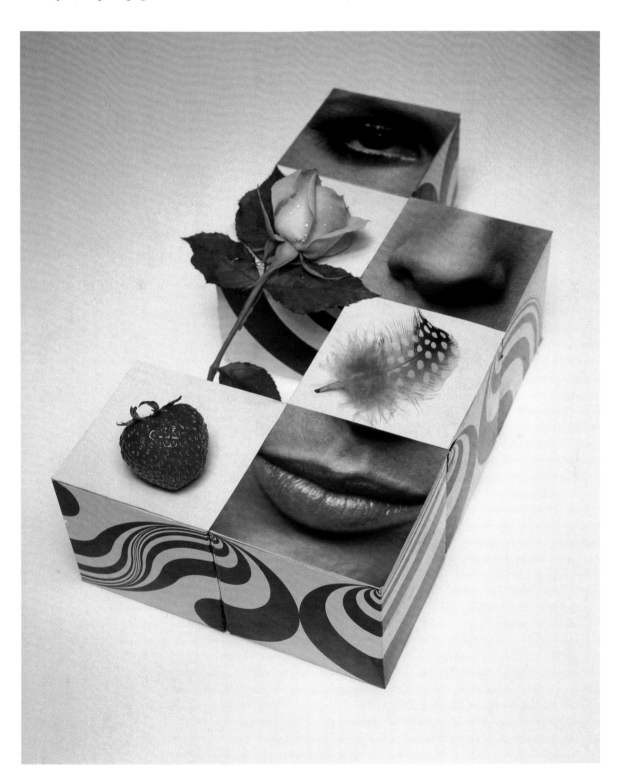

Photographer: FRED BURRELL

for Geigy Pharmaceutical

To make this photo design, a black-and-white print made from a KODALITH Ortho Film negative of a sphygmomanometer was laid over green and red 3M Color Key Transparencies of a design pattern.

Photographer: FRED BURRELL
for Time-Life Books

A light bulb was photographed
several times in black-and-white,
each time with different reflections
on its glass surface. The negatives
were enlarged onto KODALITH
Film. Then the images were
contact-printed onto 3M Color Key
sheets of different colors, giving
this final result.

Photographer: FRED BURRELL
Marvin Warshaw
for Prentice-Hall

A black-and-white photograph of a
laboratory apparatus setup was
printed onto KODALITH Film, then
laid over 3M Color Key images of a
round light source.

Photographer: FRED BURRELL

Joe Sapinsky for *Woman's Day*/C.B.S. Publications, Inc.

A live model was placed behind a piece of frosted acetate and a cloudscape projected on her from behind, leaving her profile as a black silhouette. The "plain and mountains" in front of the silhouette are pieces of broken mirror on silver Mylar polyester film that reflect color on a contoured piece of illustration board.

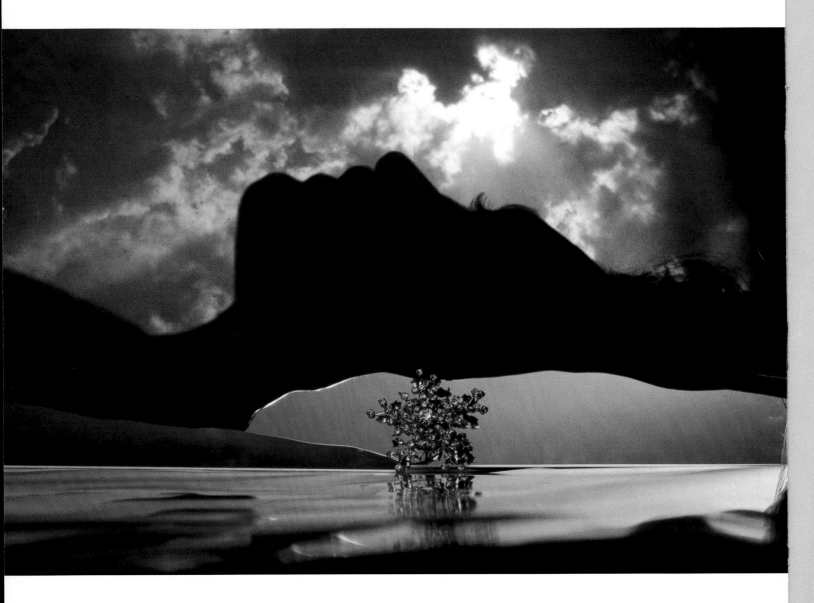

Photographer: FRED BURRELL

Jack Odette for Stinnes Corporation

To show the location of a corporation's offices, a plastic relief map was trimmed to its borders and sprayed white. The blue and purple background was made by placing theatrical gels, trimmed to follow the outline of the nation, behind frosted acetate. Spotlights raked across the surface of the map and others rear-illuminated the hazy outlines. Colored map tacks show the locations of the offices.

Photographer: FRED BURRELL

Joe Sapinsky for *Woman's Day*/C.B.S. Publications, Inc.

A man and woman meeting. A series of black-and-white photographs were assembled and then silk-screened in white onto a piece of clear acetate. Colored gels, placed behind the figures, gave them their colors. The lines and circular discs were drawn on the front of the acetate. The composite was rephotographed against a softly graduated gray background.

Photographer: CHARLES WECKLER
Weckler's World
for Boise Cascade

*The purpose of this photograph was to illustrate growth. The plant was a young
primrose which was removed from the ground carefully to keep all of the roots intact.
Then it was attached to a large sheet of clear glass with florist's putty. I had located a
western hill over which the sun would set and positioned the glass sheet vertically some
distance across the valley so that the brow of the hill and the primrose would position
properly in the camera ground glass. At sunset, I took a series of exposures using a
Hasselblad camera with a 150 mm lens on CPS120 color negative film. The print was
made using a Bourges Colortone Sheet, 10 percent white, as a texture screen in contact
with the negative.*